QUABBIN RESERVOIR
THROUGH TIME

JOHN BURK

AMERICA THROUGH TIME is an imprint of Fonthill Media LLC

Fonthill Media LLC
www.fonthillmedia.com
office@fonthillmedia.com

First published 2013

Copyright © John Burk 2013

ISBN 978-1-62545-014-2

All rights reserved. No part of this publication may be reproduced, stored in a retrieval system or transmitted in any form or by any means, electronic, mechanical, photocopying, recording or otherwise, without prior permission in writing from Fonthill Media LLC

Typeset in Mrs Eaves XL Serif Narrow
Printed and bound in England

Connect with us:
www.twitter.com/usathroughtime
www.facebook.com/AmericaThroughTime

AMERICA THROUGH TIME® is a registered trademark of Fonthill Media LLC

Introduction

The year 2013 marked the seventy-fifth anniversary of the disincorporation of the Swift River Valley towns that were abandoned during the creation of Quabbin Reservoir, the water supply for more than two million residents in the greater Boston area. Over that time, the reservoir and its surrounding lands have become well known as southern New England's largest conservation area, a forty-square mile wilderness with abundant wildlife, outstanding scenery, and diverse natural habitats.

Amidst the natural splendor are countless artifacts such as stone foundations, mill and bridge sites, abandoned roads and railroad beds, and empty village greens that serve as reminders of the region's fascinating and controversial past. This picturesque valley was once home to quaint small towns and villages that were nestled amidst rolling hills and ridges. Riverside communities such as Enfield and North Dana were prosperous industrial centers, while the lakes, ponds, camps, and hotels of Greenwich, Dana, and other villages attracted many visitors from the congested cities of the Northeast. Anglers enjoyed excellent fishing in the watershed's many streams and brooks.

After struggling for three centuries to provide adequate resources for eastern Massachusetts' constantly expanding population, planners turned to the well-watered valleys of central Massachusetts to alleviate the state's ongoing water crisis. In 1895, construction began on the Wachusett Reservoir, formed by an impoundment of the Nashua River near Worcester. Hundreds of residences were taken by the state, setting an ominous precedent for future projects. Though Wachusett Reservoir was the world's largest artificial reservoir when it opened in 1905, within a matter of years it was evident that even larger sources were needed to satisfy Boston's demand.

By the onset of the twentieth century, rumors abounded that the Swift River Valley was destined to become the site of a massive reservoir that would necessitate the abandonment and flooding of several towns, and by the 1920s the project became reality. With their light population and lack of prominent landmarks, the valley residents were powerless against the interests of eastern Massachusetts, and the construction of the 'Quabbin' (a Native term for 'meeting of the waters') Reservoir was officially authorized in 1927. A large portion of the nearby Ware River Valley was also added to the water supply network, necessitating the abandonment of several additional villages in that watershed.

Over the next decade, the Swift Valley underwent a marked transformation. Four towns – Enfield, Greenwich, Dana, and Prescott – were entirely abandoned, and portions of

neighboring communities such as New Salem and Pelham were also taken over by the Water Commission. Nearly 3,000 residents experienced the sad reality of seeing their homes and way of life razed and literally wiped off the map. Laborers cut trees and burned brush to clear the reservoir floor, and the once scenic valley resembled a barren war zone by the late 1930s.

Despite its size, the reservoir was a relatively simple engineering project, as the valley's hills and ridges formed a natural bowl. The massive Winsor Dam impounded the main stem of the Swift River at the valley's southwest corner, while the Goodnough Dike kept the water from draining away to the southeast. Water was conveyed to the Wachusett Reservoir by gravity via a concrete aqueduct. The projects were well-timed from a financial perspective, as Depression-era wages allowed them to be completed under budget.

Poignant farewell ceremonies, including a well-attended ball in Enfield, were held in several of the valley communities during the spring of 1938, when the towns were officially discontinued. The last holdout residents left shortly thereafter. In August 1939, the first waters began to back up behind the Winsor Dam, and the reservoir gradually filled to its 512 billion gallon capacity over the next seven years.

In spite of the controversies, an undeniable benefit to these projects was the creation of an extensive network of conservation land in the heart of a densely populated region. Quabbin Reservoir is by far the largest lake in southern New England, and its extensive watershed buffer supports a variety of natural habitats and wildlife. It has served as a reintroduction area for bald eagles, beavers, wild turkeys, and deer. Wachusett Reservoir is the region's second-largest lake, and hosts a variety of birdlife including breeding common loons. The Ware River watershed boasts more than 22,000 acres of protected land with many recreational trails and thriving populations of moose and other wildlife.

The twentieth-century implementation of the Massachusetts water supply projects has afforded a unique opportunity to witness the transformation of these landscapes through a wealth of historic sources, including photographs and postcards. Presented here is a sampling of historic and contemporary views of the lost valleys. These include the sweeping scenic vistas of Quabbin Park and the historic sites of Dana Common, which was added to the National Register of Historic Places in the spring of 2013.

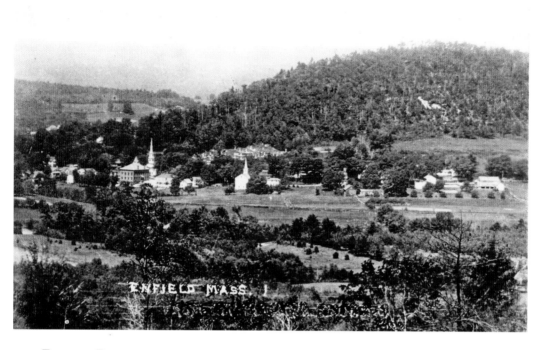

TOWN OF ENFIELD: With a modest population of roughly 1,000 residents through the nineteenth century, this was the largest of the four lost Swift River Valley communities. Formed in 1816 from land in Belchertown and Greenwich, it was a small center of industry with a number of mills. The Athol-Enfield Railroad passed through the heart of the town. Ironically, the land again became part of Belchertown after the reservoir's creation.

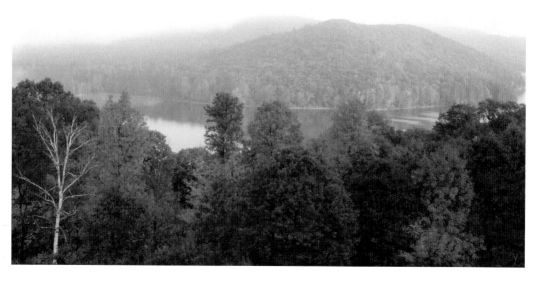

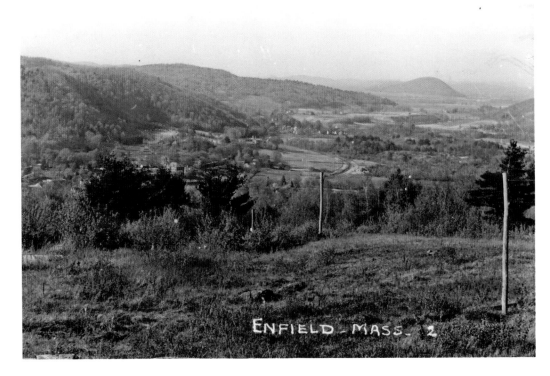

THE VALLEY TRANSFORMED: In order to clear the floor of the future reservoir, all buildings in the watershed were razed or moved, and vegetation was cut or burned from 1936 to 1939. The state workers who cut the trees were known derisively as 'woodpeckers' by Valley residents. Vegetation was removed to a height of ten feet above the flood line, while the hills, which became islands in the reservoir, remained forested.

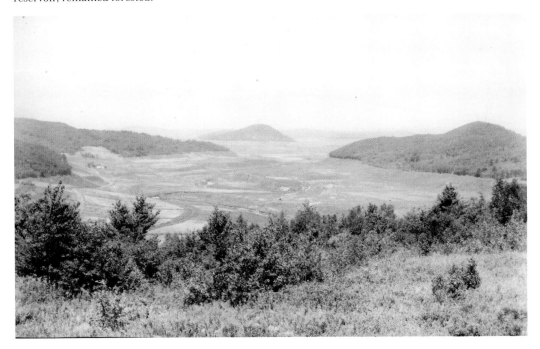

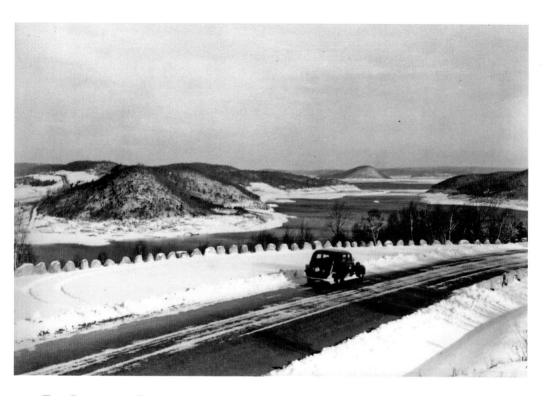

THE RESERVOIR FILLS: On August 14, 1939, the first waters began to back up behind the Winsor Dam, and by January 1941, much of the valley once occupied by Enfield was inundated. It took seven years to reach its 512 billion gallon capacity. The Enfield Lookout remains a popular stop on the Quabbin Park auto road. This shoulder of Quabbin Hill offers sweeping panoramic views up the Swift River Valley to Mount Monadnock in southern New Hampshire, one of the world's most-climbed mountains.

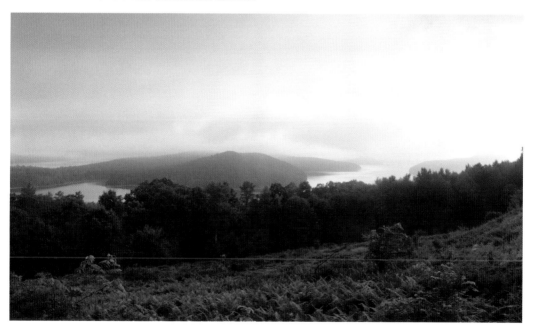

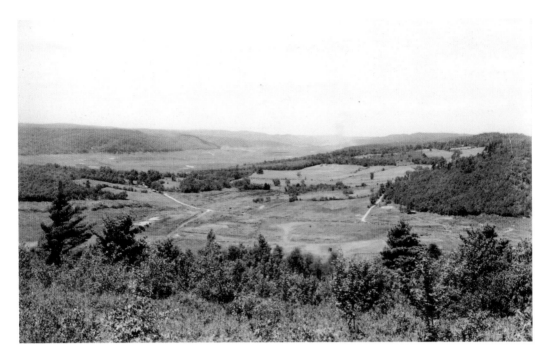

LOOKING WEST FROM QUABBIN HILL: The westerly views from Enfield Lookout offer a perspective across the southwestern arm of the reservoir to the hills of the Swift and distant Connecticut River Valleys. The Swift Valley's chains of rolling hills formed a natural bowl that made it an ideal location for an artificial reservoir. The plume of smoke on the horizon in the historic image may be burning brush during the clearing of the reservoir floor.

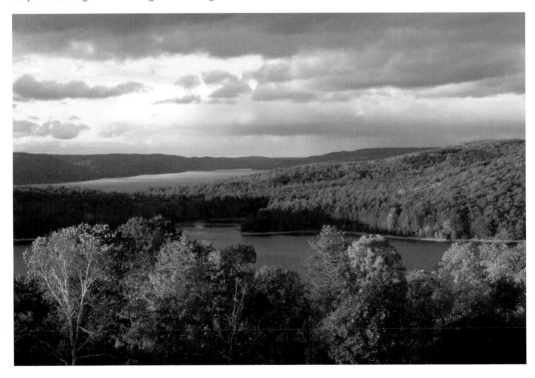

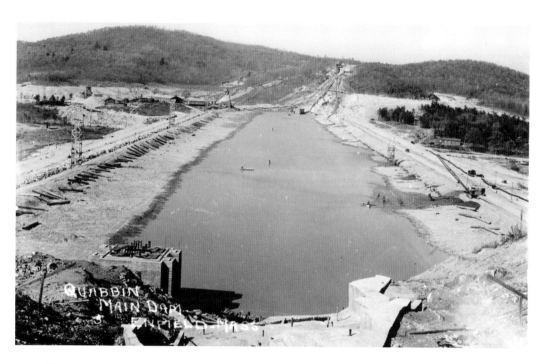

WINSOR DAM: Named for Quabbin Reservoir's chief engineer Frank Winsor, this structure is, along with the Goodnough Dike, one of two massive impoundments that form Quabbin Reservoir. It blocks the main stem of the Swift River at the valley's southwest corner. Construction began in 1935 and was completed in 1939. These views are from the west end of the dam, looking east towards the rolling hills of Quabbin Park.

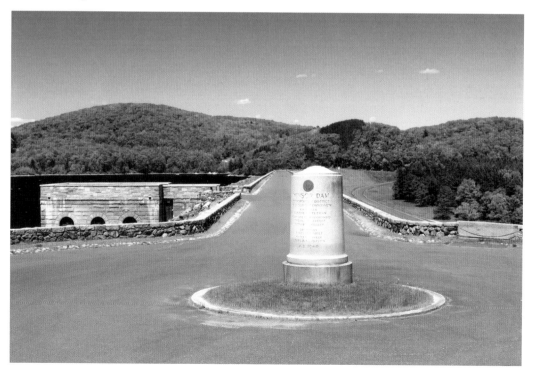

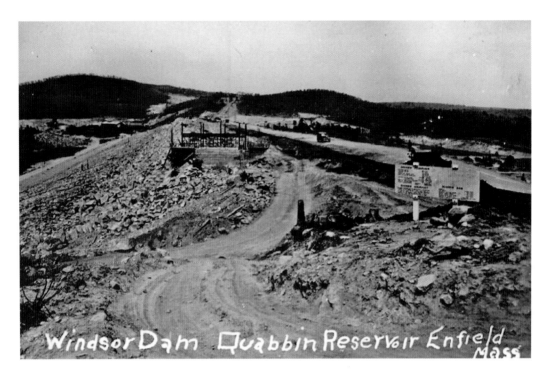

WINSOR DAM: The 2,640-foot long structure, which rises 170 feet above the riverbed, is one of the largest dams in the eastern United States. It features, and owes its strength to, a triangular profile design with a 725-foot base that tapers to 35 feet at the top. It was part of the Quabbin Park auto road until September 2001, when it was closed to vehicles after the terrorist attacks. However, walkers and bicyclists continue to enjoy fine views of the southern valley.

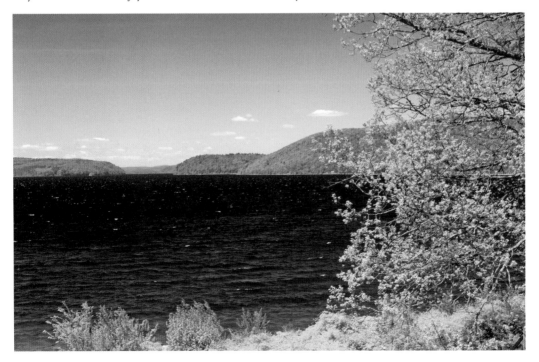

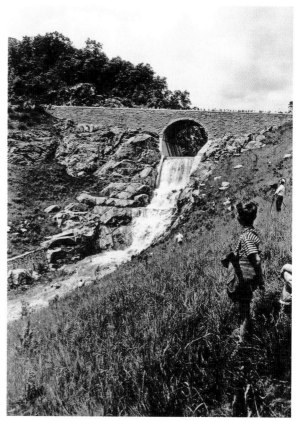

WINSOR DAM SPILLWAY:
An outlet was built at the northeast end of the dam to let surplus water out of the reservoir during periods when it exceeds its 512 billion gallon capacity. The first waters were released on June 22, 1946. After flowing below a stone arch bridge, the water cascades downslope to its confluence with the main branch of the Swift River at a pool below the dam. There are fine views of the valley from the bridge.

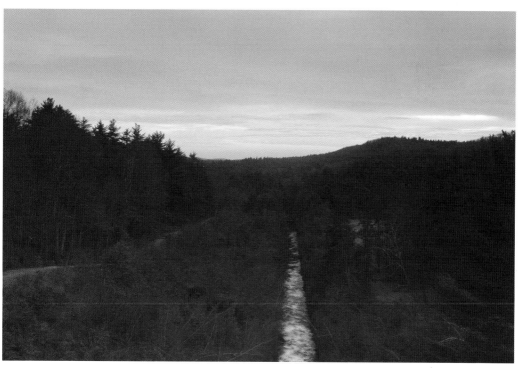

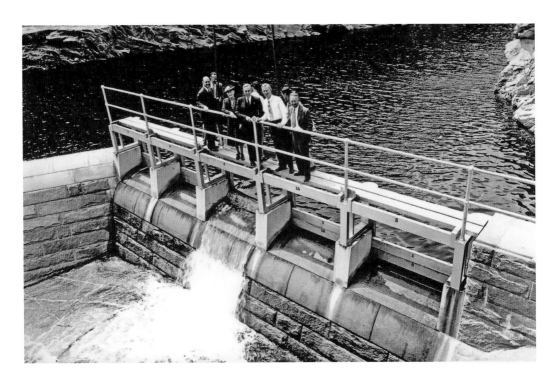

SPILLWAY AT CAPACITY: Many dignitaries and spectators attended the release of the first waters in 1946, seven years after the reservoir began to fill. During the reservoir's first half-century of operation, a period that included the prolonged drought of the 1960s and other several other dry periods, the spillway was used roughly forty percent of the time. Today visitors continue to enjoy views of the gorge, wildlife such as common ravens and waterfowl, and colorful fall foliage.

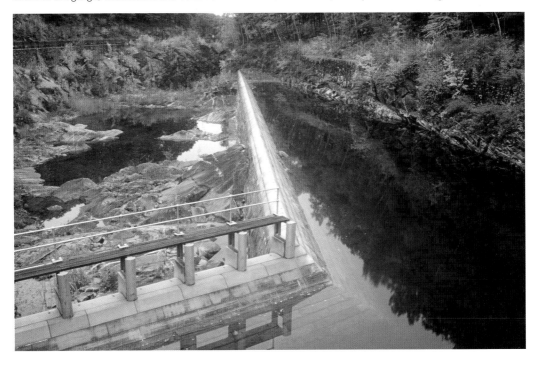

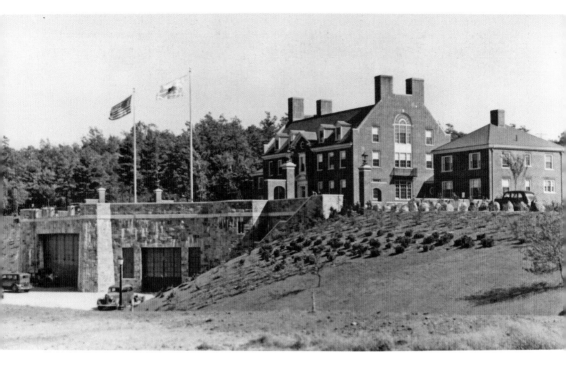

HEADQUARTERS BUILDING: The Quabbin Reservoir administration building was built at the west end of Winsor Dam during the 1940s. The hangars beneath the road are used for patrol boats. They were originally designed for seaplanes, which were proposed for reservoir patrol but never implemented. The Quabbin Park visitor center was established in the facility in 1984. During the reservoir's construction, the former Chandler residence in Enfield, which was the last building remaining in the valley, served as project headquarters.

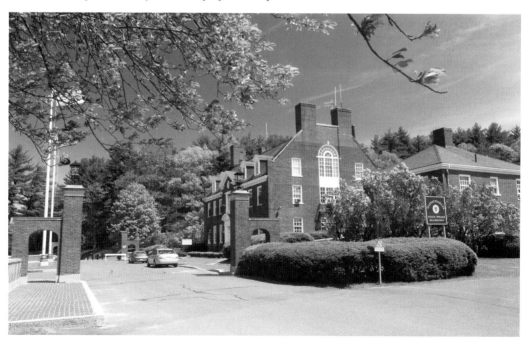

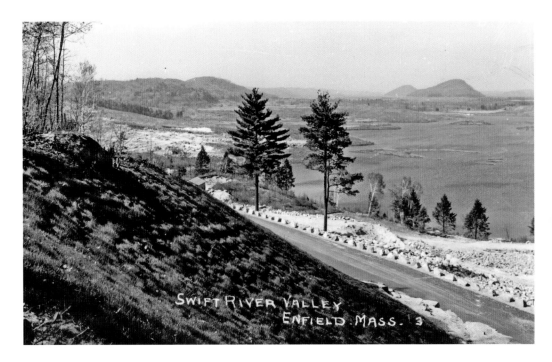

QUABBIN PARK: The main visiting area is situated at the reservoir's southern tip in the towns of Belchertown and Ware. A 5.3-mile auto road offers visitors easy access to many features and attractions, including Winsor Dam, Goodnough Dike, the Enfield Lookout, Quabbin Hill, hiking trails, picnic areas, and wildlife meadows. Though maturing forests have obscured some of the old views, there are many scenic vistas.

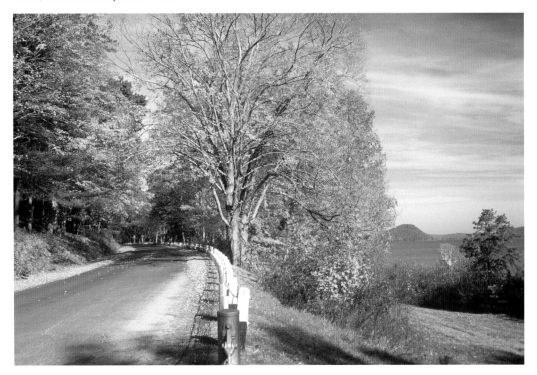

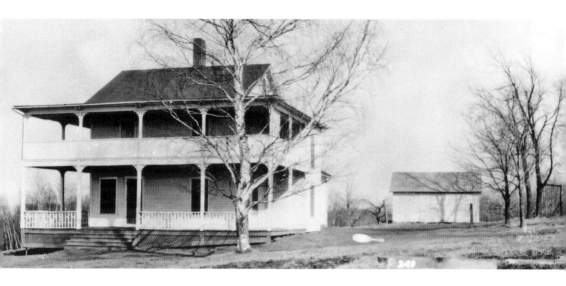

QUABBIN HILL: Also historically known as 'Great Quabbin Mountain,' this 1,033-foot eminence is the highest point in Quabbin Reservation. Its first settler was Aaron Woods, founder of the Enfield Congregational Church, who built a home in 1785. Before the Enfield church was built, he walked five miles every Sunday to attend services in Greenwich. The homestead included an ice house, pond, and dam. Five generations of the Woods family lived on the hill before the land was taken for the reservoir.

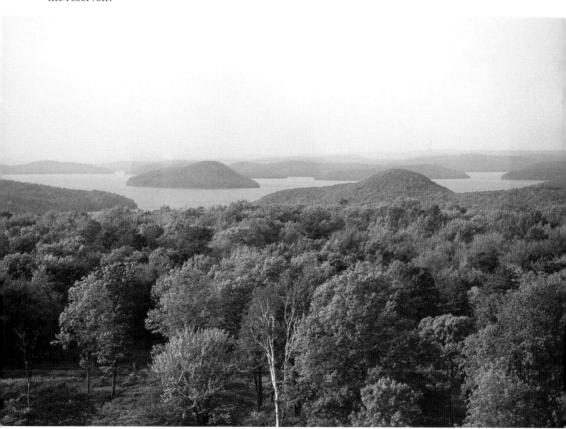

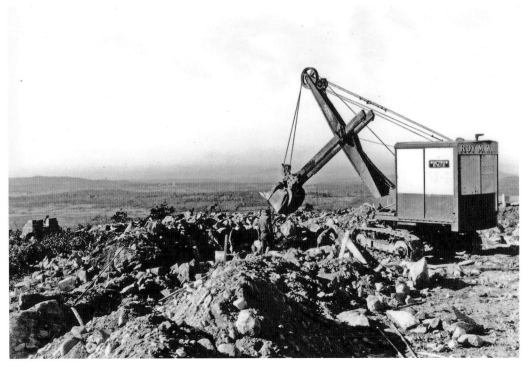

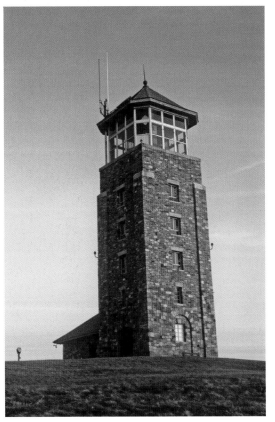

OBSERVATION TOWER:
This stout, eighty-four-foot high stone structure was built atop Quabbin Hill in 1941. Visitors enjoy 360-degree panoramic views across central New England that include Mount Monadnock in southern New Hampshire, Wachusett Mountain in eastern Massachusetts, the hills of the Connecticut River Valley, and Mount Greylock in the Berkshire Hills, some sixty-five miles away to the west.

ENFIELD PAST AND PRESENT: After the reservoir project was approved, the state undertook the lengthy process of negotiating with the landowners in the doomed towns and villages for compensation for their properties. The settlements were generally undesirable to the residents, due in part to Great Depression-era economic conditions. Though most of Enfield's old neighborhoods are underwater now, this old orchard on the slopes of Quabbin Hill offers a glimpse of the past and provides habitat for a variety of wildlife.

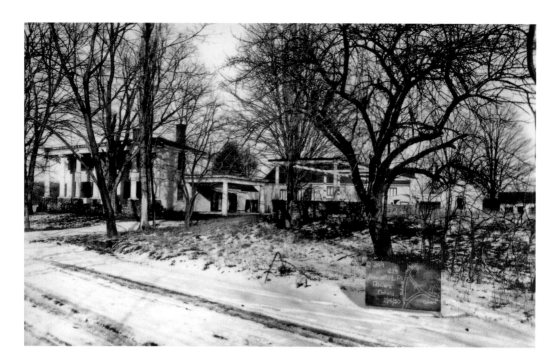

POWERS HOME: Today the lost homes of the Swift River Valley are marked by stone foundations that serve as reminders of the residents who were displaced by Quabbin Reservoir's creation. One of the most prominent ruins in Quabbin Park is the former residence of L. J. Powers, which is distinguished by its six hefty pillars. The site is at the base of the old Webster Road opposite the fields at 'Hank's Meadow.' The road is now part of a popular hiking trail.

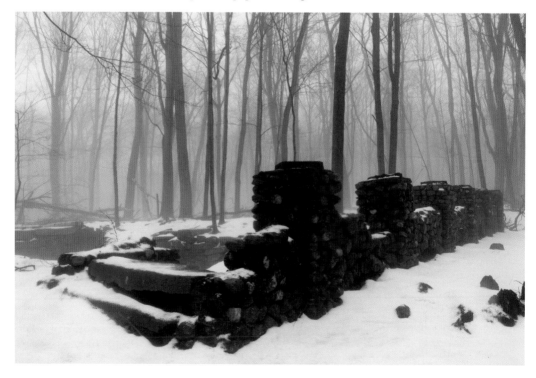

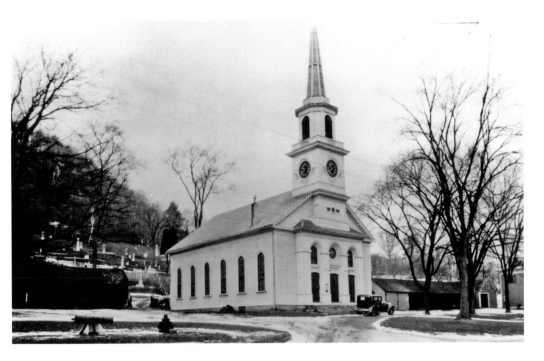

ENFIELD CHURCH: The stately Enfield Congregational Church was lost in a suspicious fire in 1936, shortly before the building's 150th anniversary. Behind the building is the cemetery at the base of Mount Ram at the southern tip of the Prescott Peninsula. After the valley was flooded, the old cemetery terraces remained visible from the Enfield Lookout. The fields and shoreline at Hank's Meadow offer views across the water to Mount Ram.

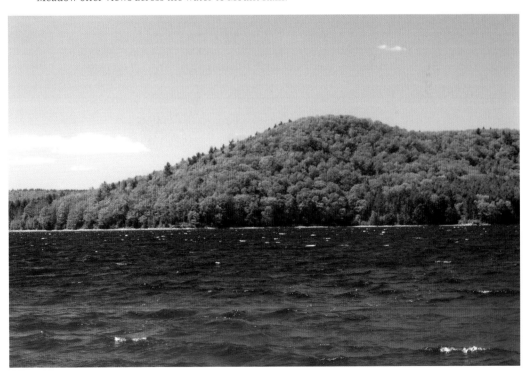

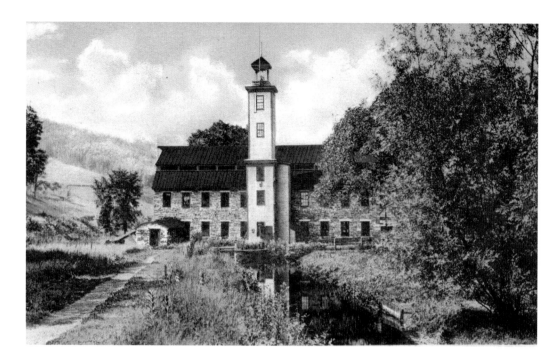

FROM MILL TOWN TO WILDERNESS: Thanks to its location at the confluence of the Swift River East and West Branches, Enfield had the largest concentration of industry of the four lost towns. The Enfield Manufacturing Company, which produced a variety of wool products, was established in the town center during the late 1800s and provided employment to many residents. Today the lowlands are underwater, while deer and other wildlife roam the uplands, including the meadows and fields of Quabbin Park.

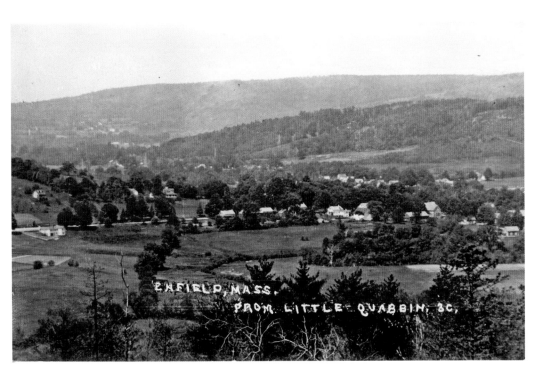

LITTLE QUABBIN HILL: Another of Enfield's prominent geographic landmarks, this modest eminence offered a fine perspective of the town and valley from the east. Now the southernmost of Quabbin Reservoir's main islands, it, like Mount Ram, is visible from the shoreline in Quabbin Park. Once hills or highlands in the valley, the reservoir's many islands total roughly 3,500 acres with more than sixty miles of shoreline; all are off-limits to the public.

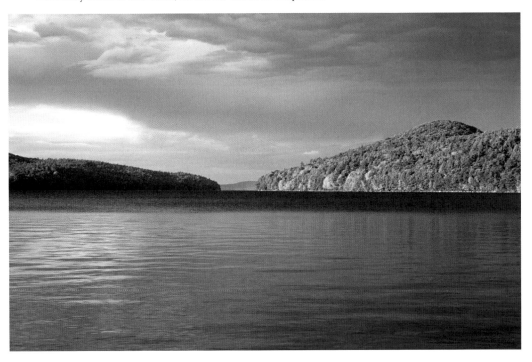

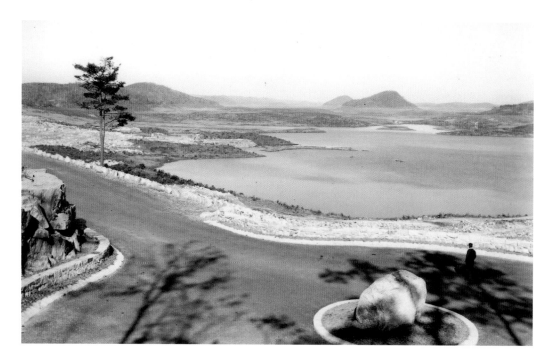

GOODNOUGH DIKE: Similar in design to the Winsor Dam, this impoundment blocks the waters of Beaver Brook at the reservation's southwest corner in Quabbin Park, thus keeping the reservoir waters from draining away to the Chicopee River watershed. It was built between 1933 and 1938. Because it has no release tunnel or spillway, it is not a true dam. This viewpoint is now part of an interpretive trail that also details forest management.

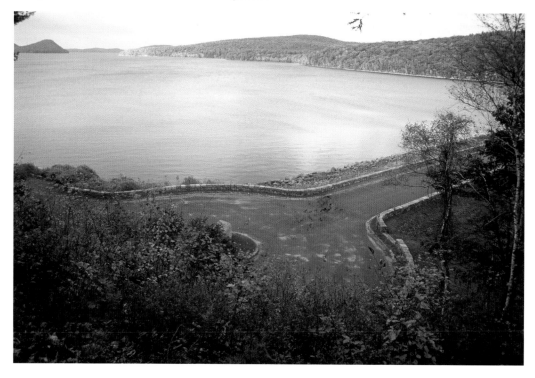

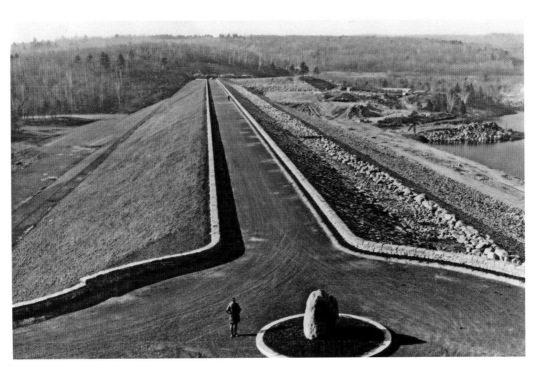

GOODNOUGH DIKE: With an 878-foot wide base that tapers to 35 feet across the top, the stout design was similar to that of the Winsor Dam. The downstream side was covered with soil, while upstream was reinforced with stones. Like the dam, the structure was also once part of the park road, but has been closed to public vehicles since September 2001. The road now is a popular walking loop with fine views of the reservoir and valley of Beaver Brook.

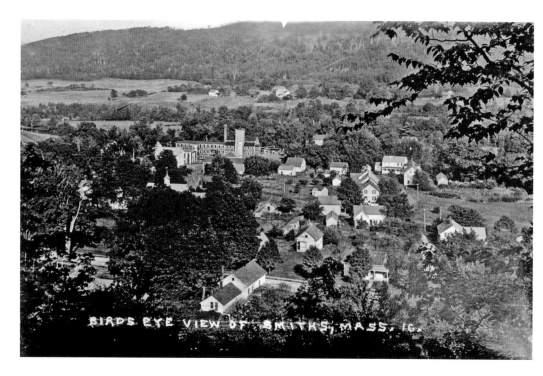

SMITH'S VILLAGE: Also known as the 'Upper Village,' this was one of Enfield's two main residential areas. It was situated north of the town center on the East Branch of the Swift River at the base of Little Quabbin Hill. The dominant institution was the Swift River Company, a well-known cotton manufacturer whose buildings included grist and saw mills, a box factory, and company store and post office. The cotton and wool mill products were renowned worldwide for their quality.

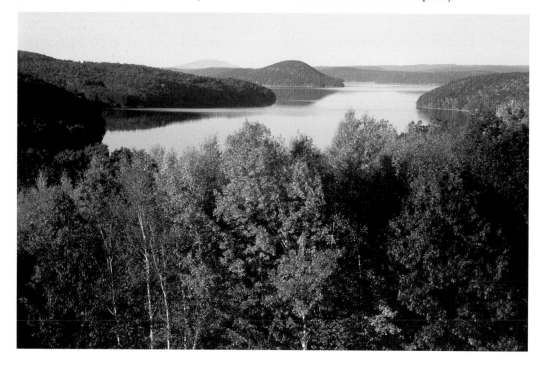

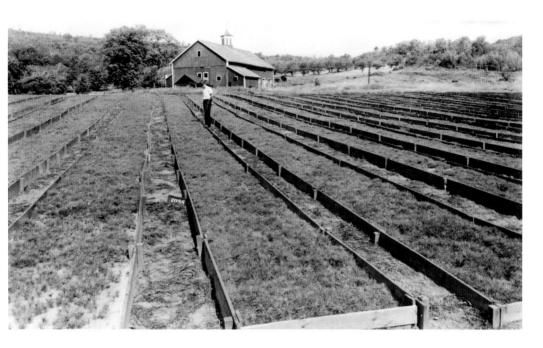

FOREST MANAGEMENT: Quabbin Reservoir's extensive woodland buffer helps ensure water quality. During the 1930s, seedlings were prepared at several nurseries to reforest the shores. Many red pines, which are not native to the region, were planted because it was originally (and erroneously) believed that they offered the greatest water yield. In the historic image, engineer Russell Snow inspects the young sprouts. Many of the plantations have been harvested to promote native species and create wildlife habitat.

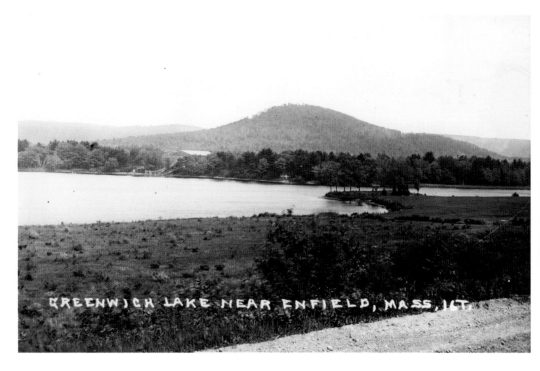

GREENWICH LAKE: Nestled in the valley beneath Little Quabbin Hill, Mount Lizzie, and the Prescott Peninsula, this picturesque attraction is one of many waterbodies that are now below the surface of Quabbin Reservoir. It was the source of the town of Greenwich's largest and most lucrative winter industry, as more than 100,000 tons of ice were cut and exported to cities throughout the Northeast annually.

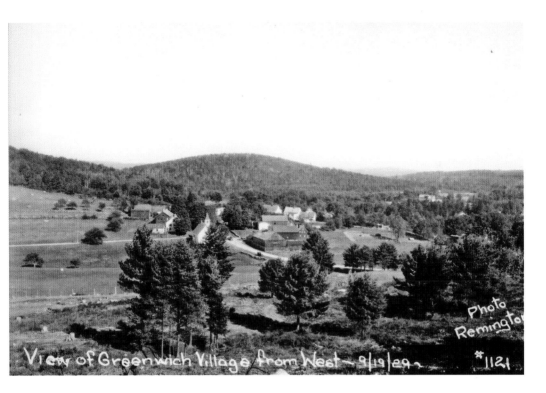

GREENWICH VILLAGE: This hamlet was located offshore west of the present baffle dams near Gate 43 and north of Quabbin Lake. Among its institutions were a post office and the Riverside Inn. Apart from the high valley hills, Greenwich is entirely underwater now. Today the quiet, less-traveled old roads that once connected the village to Hardwick are now frequented by wildlife such as this elusive bobcat.

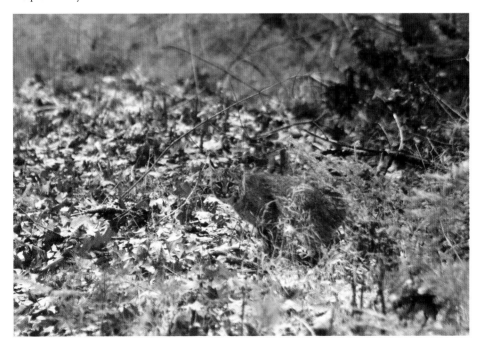

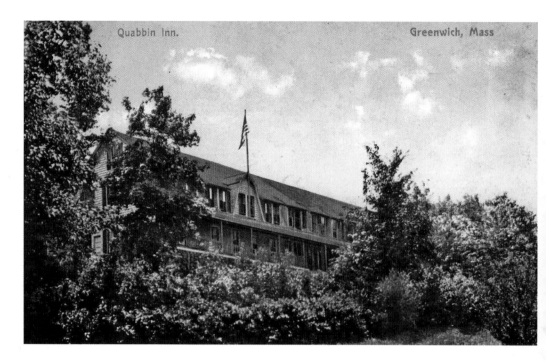

COUNTRY INNS: During the nineteenth century, the Swift River Valley was a destination for travelers seeking an escape from the Northeast's bustling and ever-growing cities. Among its most elaborate hostelries was the Quabbin Inn in Greenwich, which overlooked Quabbin Lake. Today the Nichewaug Inn, which is located in the center of Petersham, offers a glimpse of the past. Though the future of this abandoned structure is uncertain, for now it is a prominent attraction of the town's historic common.

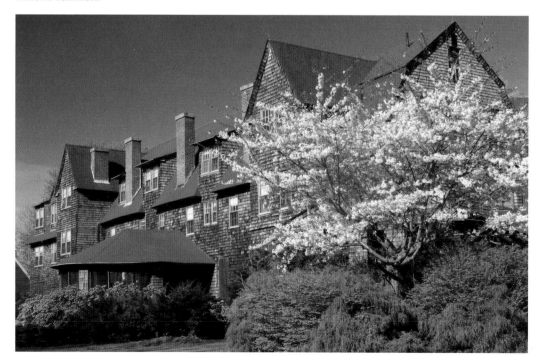

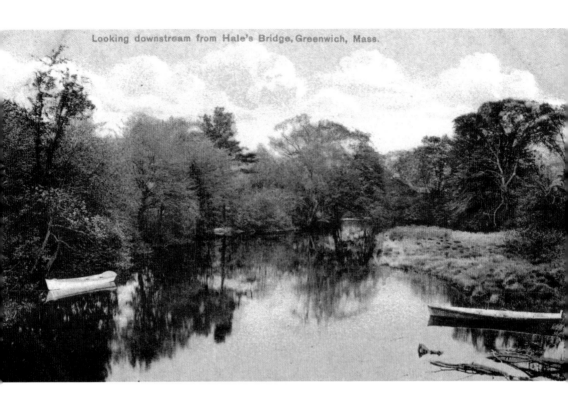

A HAVEN FOR WILDLIFE: Greenwich was well known for its lakes, ponds, and rivers, which attracted many summer visitors. Hale's Bridge spanned one of the many waterways in the watersheds of the East and Middle Branches of the Swift River. Quabbin Reservoir now hosts the state's largest concentration of common loons, which arrived after it filled. Roughly a dozen breeding pairs of this iconic wilderness symbol frequent its waters annually.

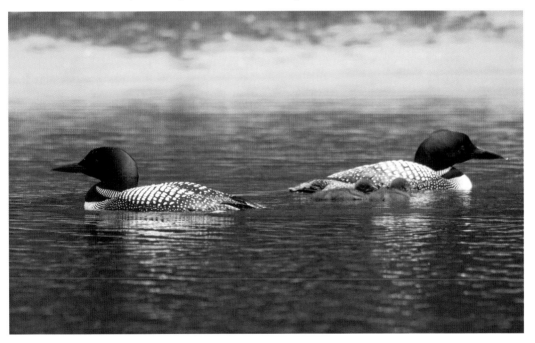

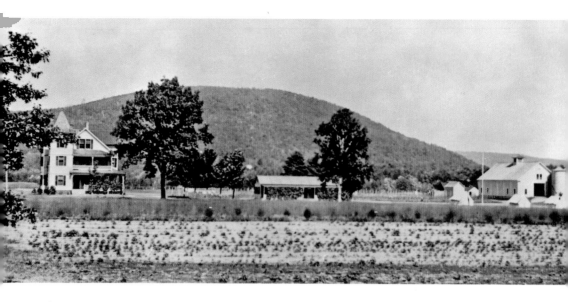

GREENWICH HILLSIDE SCHOOL: Aptly named for its location below Mount Pomeroy, this private farming school was established in 1901 to provide vocational training for disadvantaged youths. The three-story dormitory house is visible on the left, with the farm barns to the right. Mount Pomeroy is now one of the largest islands in Quabbin Reservoir. The shoreline near Gates 45 and 46 in Hardwick offers fine westerly views across the water to the islands.

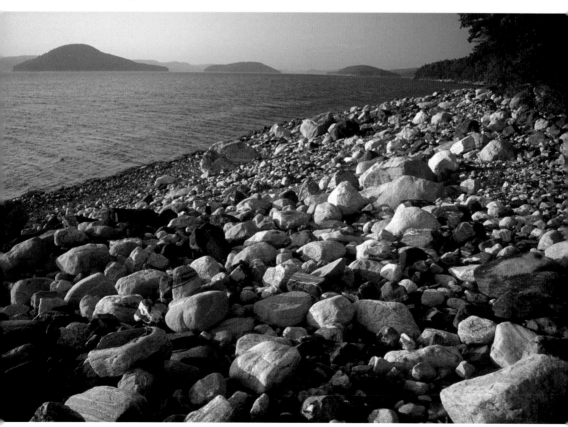

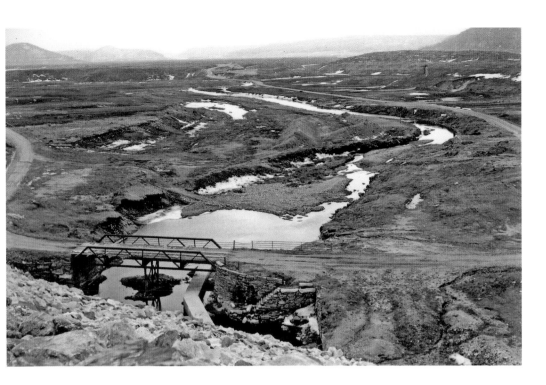

BAFFLE DAMS: These little-known components of Quabbin Reservoir's engineering were built near the east shores near the former site of Greenwich Village. The impoundments guide inflow from the East Branch of the Swift River and the Ware River away from the outlet. This allows the water to circulate around the reservoir for roughly three years, which improves water quality. The north dam is nearly one-third-of-a-mile long, and the south is 565 feet long.

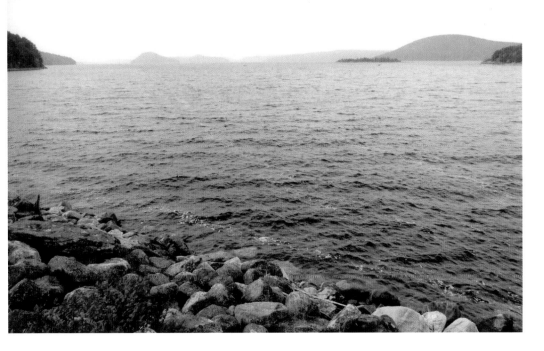

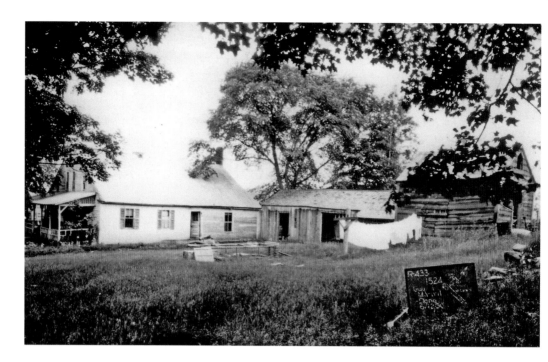

MARVEL HOUSE: Storrsville, a tiny village east of Dana, was home to the last holdout in the Swift Valley, farmer and fish hatchery owner Guy Marvel. Unsatisfied with the compensation for his land, he filed several lawsuits. A security guard was assigned to allow his family on and off the property. After finally vacating in December 1941, he bought the land across the highway to spite the state. Beavers now frequent the wetland opposite the house site near Potapaug Pond's inlet.

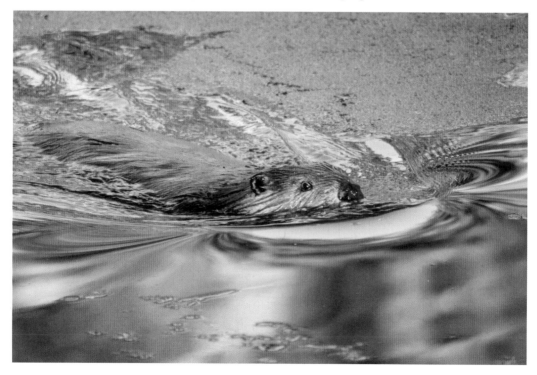

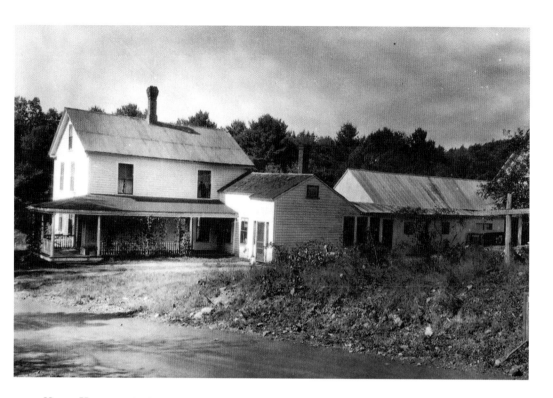

HALL HOME: The former Dana-Petersham Road, which leads to the famous Dana Common historic site, is itself home to several old house and farm sites. The residence last owned by Sheridan Hall was located adjacent to the present Gate 40 parking area. One of the previous owners was Asa 'Popcorn' Snow, a colorful character who built himself a casket with a glass window so coroners could confirm he was deceased. A forest stream crosses the road near the house site.

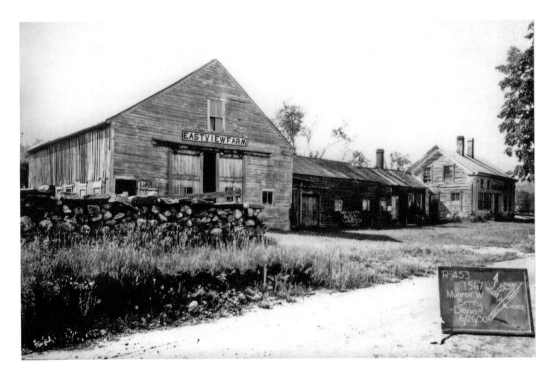

EASTVIEW FARM: This is the easternmost of several old farm sites along the Dana-Petersham Road. Owner Munroe Berry also served as Dana's animal inspector during the 1930s. The barn foundation and stone walls are visible on both sides of the road between the former agricultural fields, which are maintained as meadows that benefit a variety of wildflowers and wildlife, including grassland birds, bobcats, foxes, coyotes, and deer. The shack is used as a checking station during the annual Quabbin deer hunt.

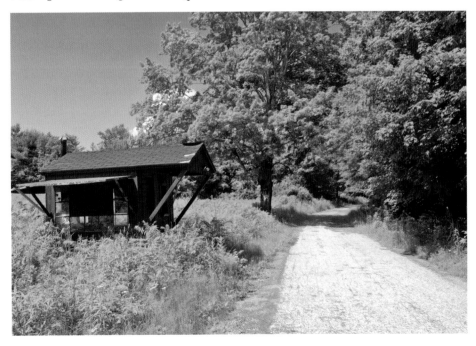

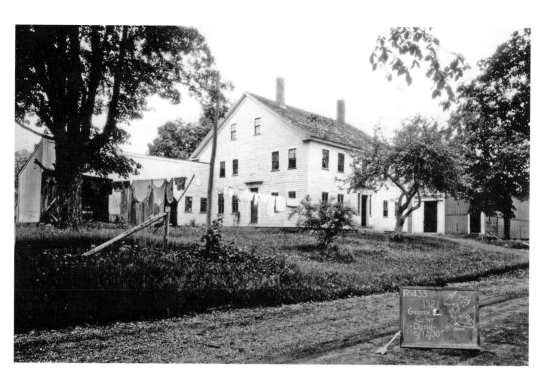

CARTER'S POOR FARM: Many rural New England towns once had community farms where those in need could perform chores in exchange for room and board. George Carter's property served such a purpose for Dana residents. The large barn foundation is easily visible on the north side of the road, roughly one mile from Gate 40. Another legacy of the agricultural past is the grove of apple trees along the perimeter of the old fields, which are now maintained as open meadows.

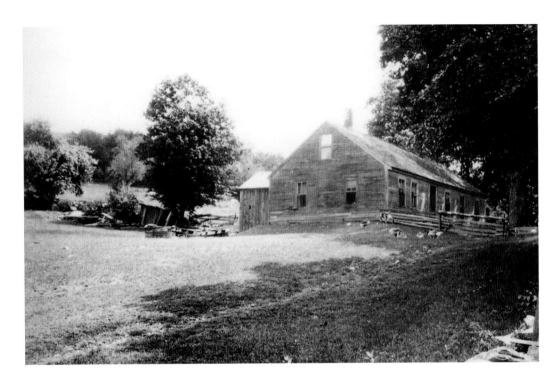

SPOONER FARM: A short distance east of Dana Common is another old field and foundation that marks the site of the property last owned by Ed and Lulu Spooner. Colorful periwinkle flowers grow in and around the foundation in spring. The family relocated to the neighboring town of Barre after selling the property to the Water Commission in 1931. The forest groves adjacent to the site offer colorful fall foliage for hikers and cyclists as they near the common.

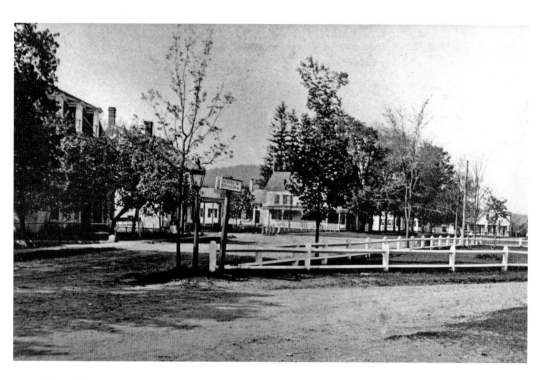

DANA COMMON: The former town center, which was added to the National Register of Historic Places in 2013, is Quabbin Reservoir's best-preserved historic site. Roughly thirty buildings once lined this classic New England green. Though abandoned because of its proximity to the watershed, the village was not flooded, and as a result its many old stone walls, foundations, and roads remain visible today. Dana was originally established from a portion of neighboring Petersham in 1801.

PRESERVING DANA COMMON: Even though the buildings are gone, the center's historic appearance is considerably enhanced by regular mowing of the old village green and fields adjacent to the former residences. This practice offers the dual benefit of preserving the historical appearance and creating habitat diversity for wildlife such as Monarch butterflies. Some of the trees on the common in the historic image have been removed.

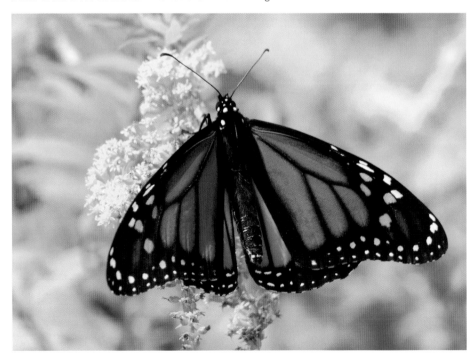

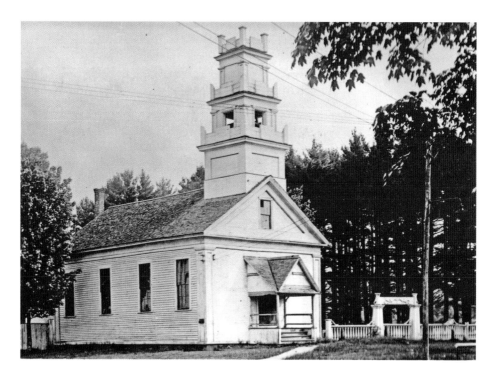

DANA TOWN HALL: First built as a Baptist church in Petersham, this structure was moved to Dana in the early nineteenth century. It was converted to a municipal building after being sold in 1842, and also was used as a school. It was often mistaken for the Congregational church across the road. The building was sold to the Water Commission in 1938 and scrapped for timber. The foundation and a concrete walkway, which once led to the front door, mark the site today.

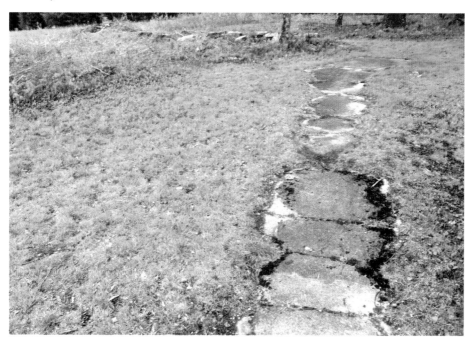

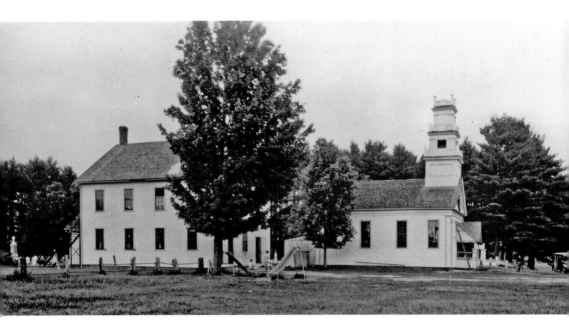

CENTER SCHOOL: The village schoolhouse was located on the northeast corner of Dana Common adjacent to the town hall, which is visible on the right in the historic image. It was one of four small schools that once operated in Dana's villages, two of which closed after 1895. The sites of both buildings are visible on the north side of the junction where the Dana–Petersham Road ends at the village green.

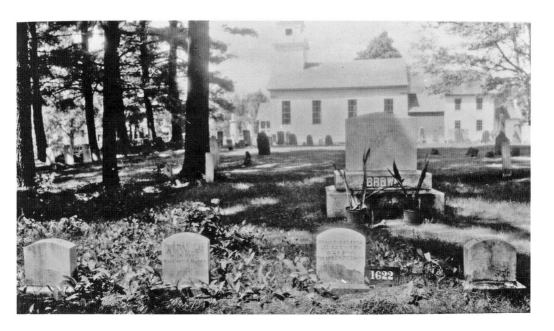

DANA CEMETERY: One of several burial grounds in the Swift River Valley that were relocated during the creation of Quabbin Reservoir, the Center Cemetery was located behind the school and town hall. Many of the graves were moved to Quabbin Park Cemetery in Ware. Today a line of old fence posts at the edge of a large meadow marks the former southern boundary of the cemetery.

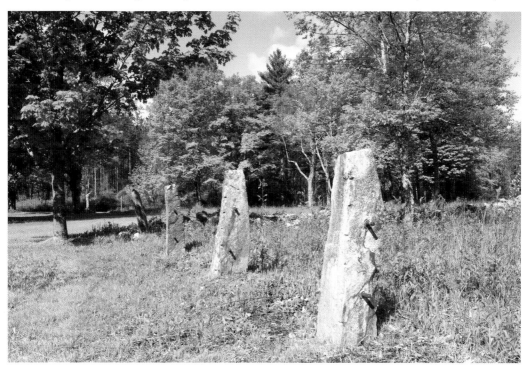

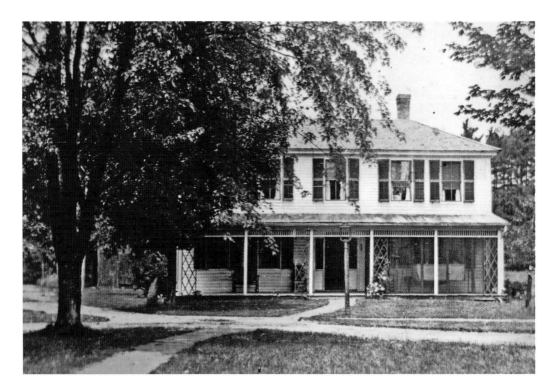

FLAGG HOME: Situated at the corner of Tamplin Road on the north side of the common, this house was last owned by Herbert Flagg, who was the grandson of a successful nineteenth-century Boston tea merchant. After graduating from Harvard and working in real estate, he returned to Dana to retire and stayed until being forced to leave in 1938. He relocated to eastern Massachusetts and decorated his new home with antiques purchased from other lost Swift Valley homes.

TAMPLIN ROAD:
This was one of several former town roads that once branched out of Dana center. After passing several old home sites and a wetland near the common, it continues north through dense woodlands for three miles to meet from roads from Gates 38 and 39 near Camel's Hump Hill in the reservation's quiet, less-traveled northeast corner in Petersham.

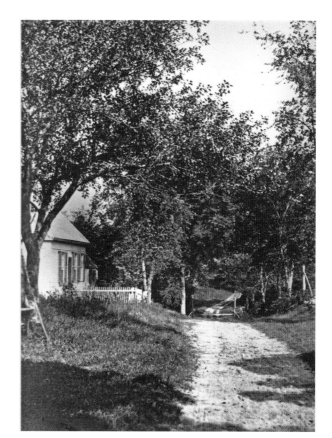

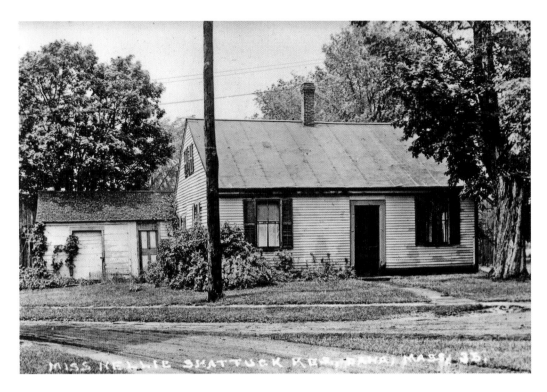

SHATTUCK HOME: The final owner of this house at the three-way junction where Skinner Hill and Tamplin Roads met the common was Nellie Shattuck, who was also the village's last librarian. Her father Irving operated a general store and was active in town government.

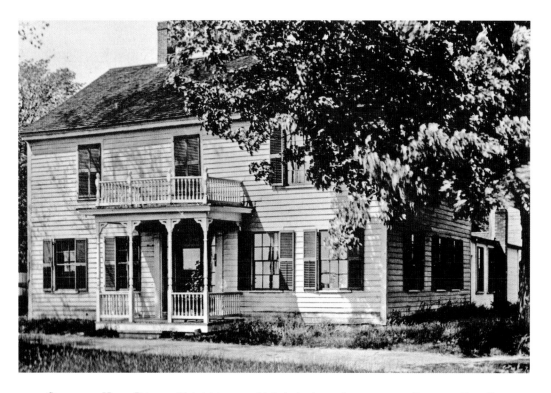

SKINNER HILL ROAD: This highway, which forks from the common adjacent to Tamplin Road, led northwesterly over Skinner Hill towards North Dana. The former home of Milton Vaughn, which was located on the east side near the common, was the site of Dana's last post office. The contemporary view is from the foundation site looking south to the common. The foundation has been filled in and the property is largely obscured.

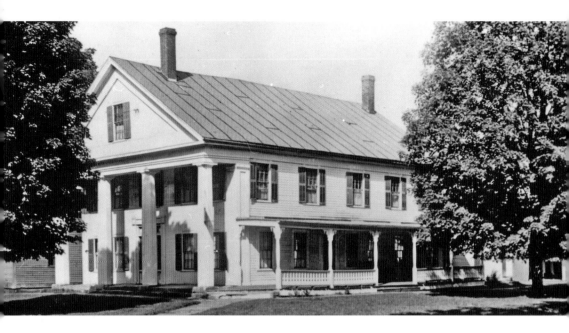

EAGLE HOUSE: Dana's first hotel, the Flagg Tavern, was built near the town center in 1835. The fifteen-room structure was subsequently moved and rebuilt at the west end of the common in 1843 by Joel Johnson. In 1893, town selectman Frank Grover purchased and renamed the facility. A porch offered a pleasant overview of the common for visitors. The large foundation is easily viewed at the junction of Greenwich and Skinner Hill Roads.

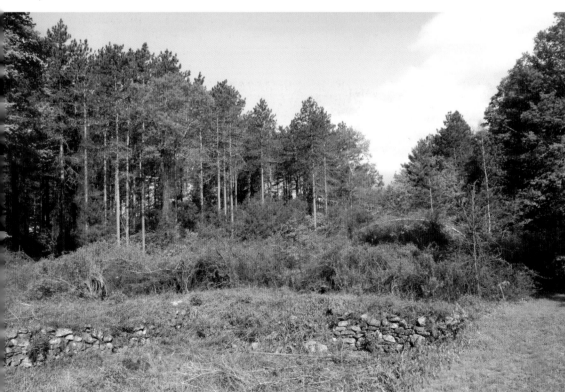

DANA COMMON SOUTHWEST: The view from the Eagle House included the nearby general store and Johnson home, which were also prominent landmarks of the village center. West Main Street and the road to Greenwich branched to the right of the store. Once frequented by town residents and children, the village green today is now visited by hikers, bikers and bird watchers. The contrast with the past is especially evident on a quiet winter day.

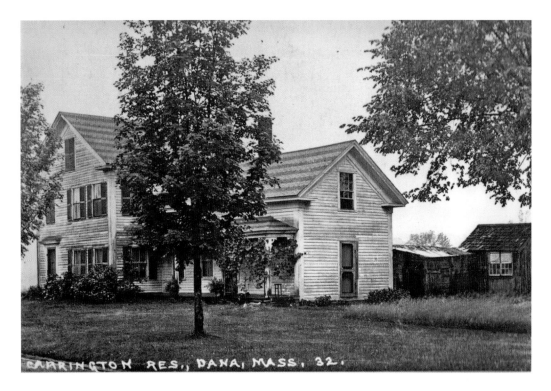

WEST MAIN STREET: Several residences were located along this road immediately west of the common, which is still paved. The former home of Ernest and Goldie Carrington was on the north side, opposite the junction with Pottapaug Pond Road. After selling the property to the Water Commission in 1931, the family relocated to Belchertown. The former Greenwich Road, which continues west from the house site, now leads visitors past wetlands and timber harvests to a scenic viewpoint on the reservoir shores.

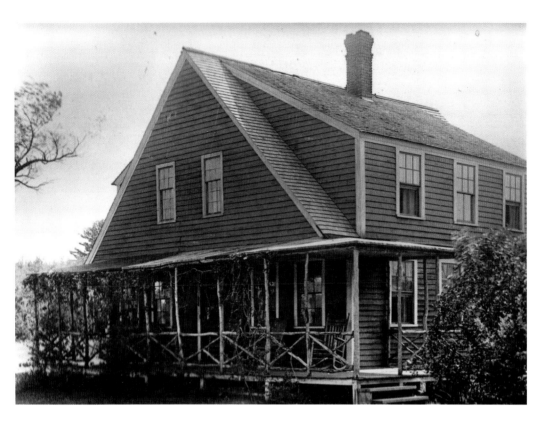

WILDES HOME: This residence, which was last owned by Ray Wildes, was tucked in a hollow on Pottapaug Pond Road a short distance below the common. It was previously owned by Gertrude and Lyman Powell. From the old home site, which is now obscured, a portion of Pottapaug Pond and a beaver wetland are visible. Pottpaug Pond Road continues for roughly one mile to its end at a picturesque viewpoint at a cove on the pond's north shores.

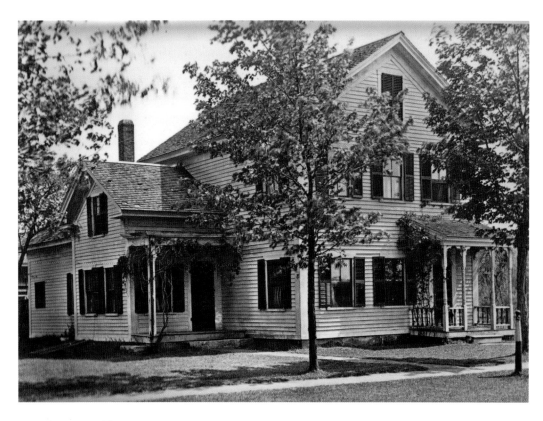

DARLING HOME: This handsome two-and-a-half-story house was situated opposite the Carrington residence at the junction of the roads to Greenwich and Pottapaug Pond. Samuel Darling, its final owner, bought the property in 1924. Though the foundation is obscured, the old front yard offers a view east to the town center.

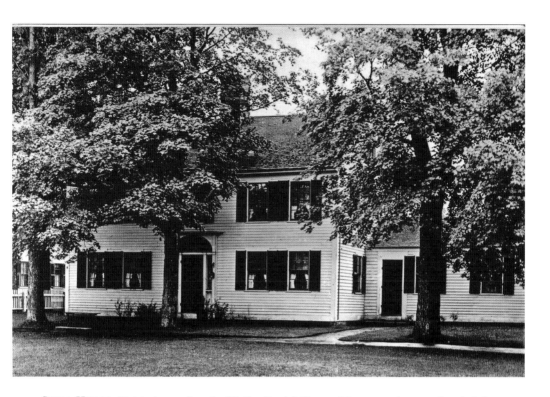

SHEA HOME: Not to be confused with the Daniel Shays of Prescott who spearheaded the famous eighteenth-century anti-taxation rebellion on behalf of Western Massachusetts farmers, Daniel Shea of Springfield was the final owner of this house on the south side of West Main Street. The Water Commission bought the property from his widow Gertrude. In addition to the stone foundation, garden flowers remain as a legacy of the old residence.

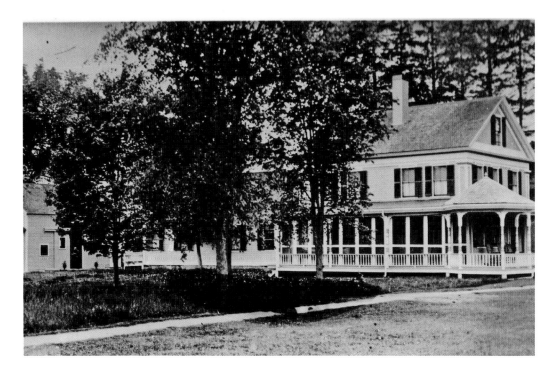

DUNN HOME: Like the homes and families that once lived there, each of Dana Common's old foundations has its own distinctive characteristics. At the site of the house last owned by Grace Dunn is an old safe that was emptied when the family moved out and left behind. A long porch stretched around the front and east sides of the building.

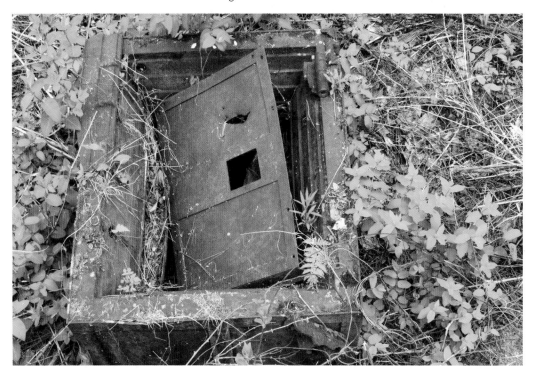

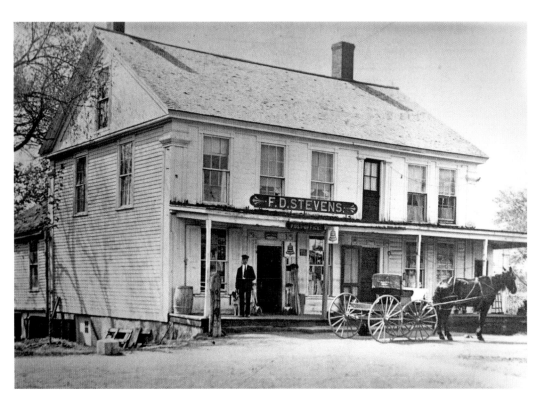

GENERAL STORE: As is the case with many New England villages, this was a hub of daily activity in Dana. The common's first store was established around 1840, and this building, which also served as the village post office, remained open until 1935. One of its last additions was a gas pump for early twentieth-century motorists. The site is distinguished from the other building remains by its concrete foundation.

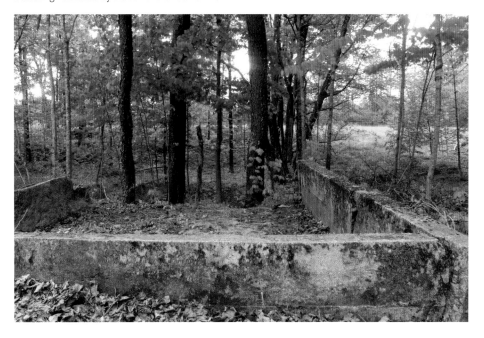

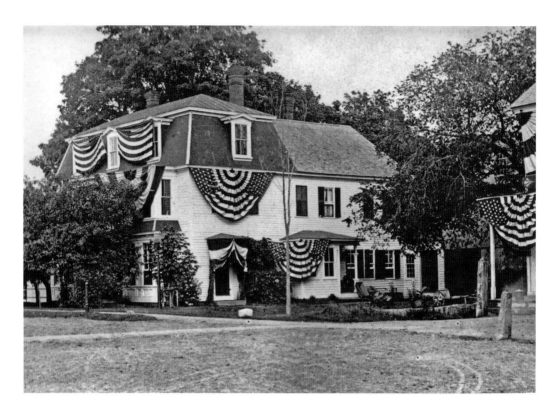

JOHNSON HOME: One of Dana's most elaborate residences, this house was located across the driveway from the Vaughn home on the south side of the common. It was substantially improved in 1884 by Nathaniel Johnson, who ran a hat factory and the village store, held positions with several local banks, and served as Dana's postmaster. Children playing on the common would often stop by the house to listen to Mrs Johnson's harp and enjoy milk and cookies.

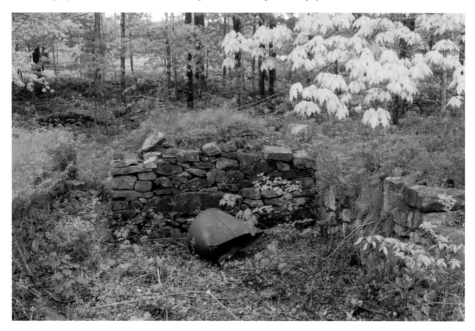

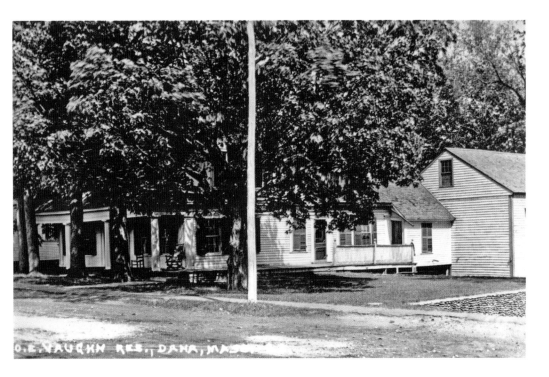

VAUGHN HOME: The former residence of O. E. Vaughn was supported by one of the most distinctive foundations in Quabbin Reservation. O. E. and his son Myron built it with rounded stones that were extracted from nearby streams and then cemented together. Now capped by a large sugar maple, the wall is a popular attraction for visitors to the common.

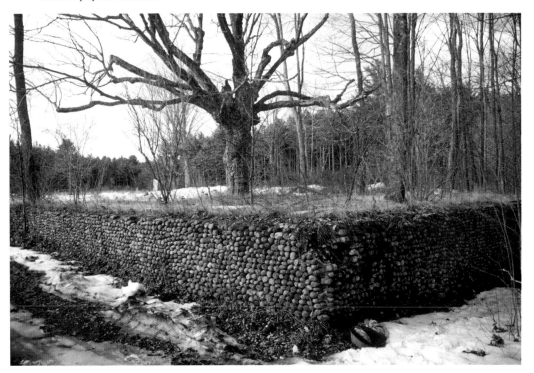

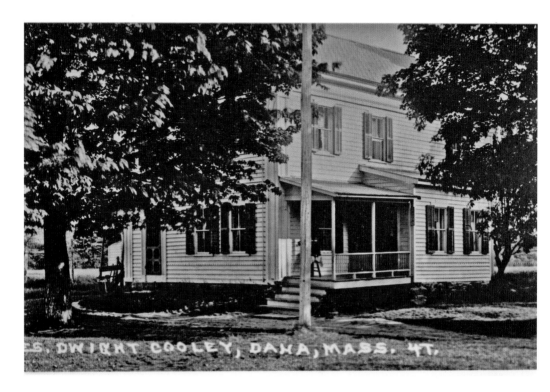

COOLEY HOME: A short driveway between the Johnson and Vaughn houses led to two residences behind the common, including the property last owned by Dwight Cooley. Today the former roadway is maintained as a grassy path through a meadow that ends in the woods on a knoll above Pottapaug Pond, Quabbin Reservoir's northeastern arm.

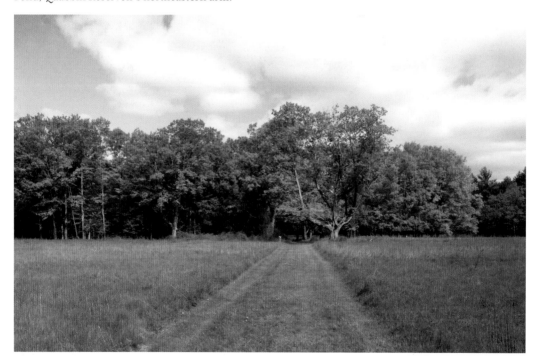

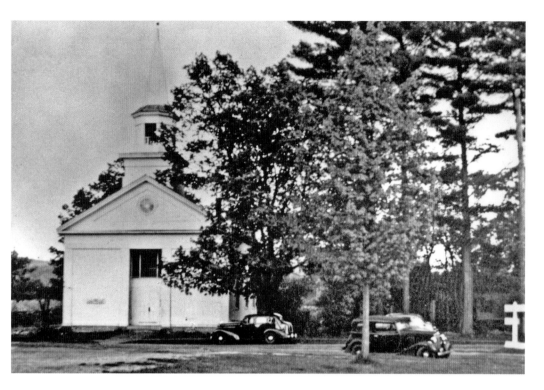

CONGREGATIONAL CHURCH: This was one of the last active houses of worship in the lost towns. It was built in 1853 at the common's east end on the south side of Petersham Road (left as one faces the monument today), and services were held through July 1938. After the building was demolished, the bell was moved to the United Penecoastal Church in Worcester.

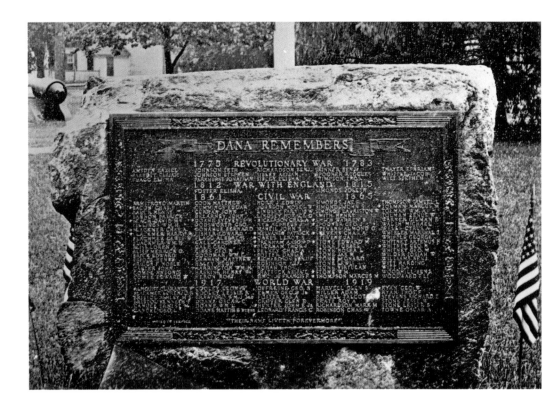

DANA MONUMENTS: Before the reservoir's creation, Dana Common's attractions included a Civil War cannon, a memorial to the town's war veterans, and a plaque dedicated to Hosea Ballou, a former Unitarian Universalist minister. These were relocated to Quabbin Park Cemetery in Ware. Today a simple stone monument at the east end of the common commemorates the residents who were displaced by the reservoir project.

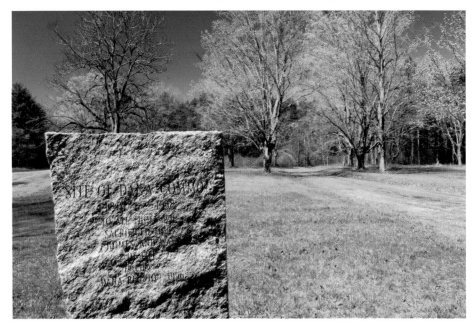

POTTAPAUG POND: The East Branch of the Swift River, Quabbin's largest source, empties into the reservoir at a complex of wildlife-rich wetlands that form the reservoir's northeastern arm. The pond's first camp was built by Col. Theodore Johnson who held legal offices and was the director of several county banks. The pond remains a popular destination for fisherman and is home to moose, bald eagles, and other wildlife. In spring and fall, flocks of migratory waterfowl use it as a rest area.

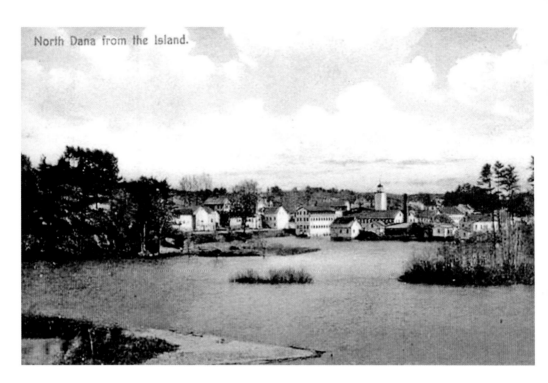

NORTH DANA: This industrial village was located north of the town center on the Middle Branch of the Swift River. Its waterways included several millponds and the East and West Branches of Fever Brook. Much of the village is underwater now, though some historic sites are hidden in the forests above the shore. The building with the tall tower in the historic image was a hat factory. The ledges of nearby Soapstone Hill offer an outstanding perspective of this valley.

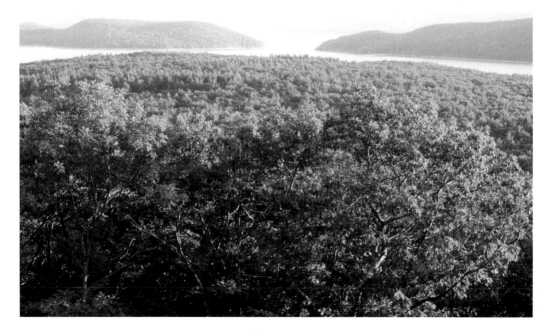

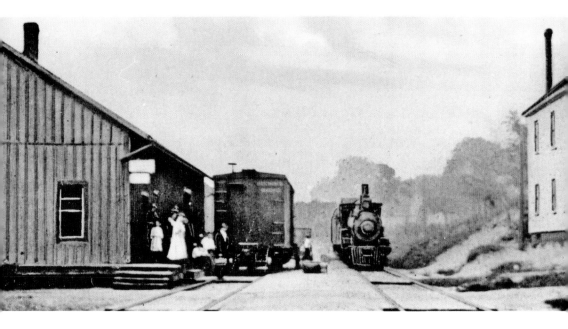

NORTH DANA DEPOT: Locally known as 'Soapstone' because of its proximity to quarries, this station was part of the Athol and Enfield Railroad, which became part of the Boston and Albany Railroad. The line was known as the 'Rabbit Run' because of its many stops, or 'hops' in the valley, or possibly because it was often used by rabbit hunters. A portion of the old bed is part of a scenic shore trail accessed via Gate 35 in New Salem.

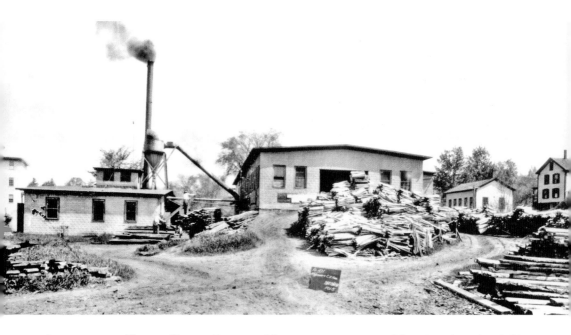

INDUSTRY IN NORTH DANA: Because of its many waterways and location along the 'Rabbit Run,' the village was an active manufacturing center with hat, soapstone, and box factories. After the reservoir's construction, the Swift River Box Company relocated to Athol, where it continued successfully. More mill and home sites are visible along the East Branch of Fever Brook at and near the former site of Doubleday Village.

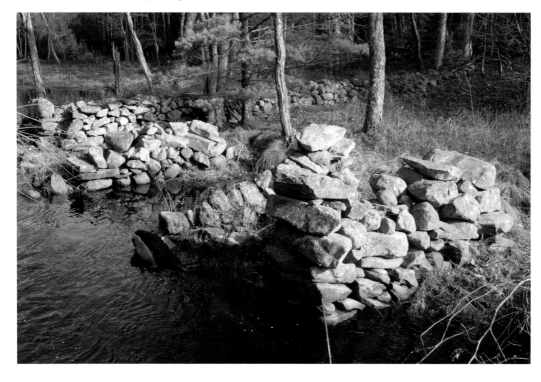

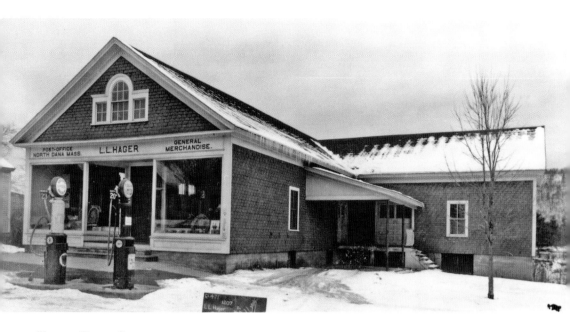

NORTH DANA STORE: Widely regarded as one of the region's finest and busiest general stores, this was one of the last remaining active businesses in the lost valley towns. Its final proprietor was Lester Hagar, who moved to Greenfield and opened a grocery after selling the property to the Water Commission. His father Otis had a long stint as Dana's last postmaster that lasted from 1893 to the village's final days during the mid-1930s.

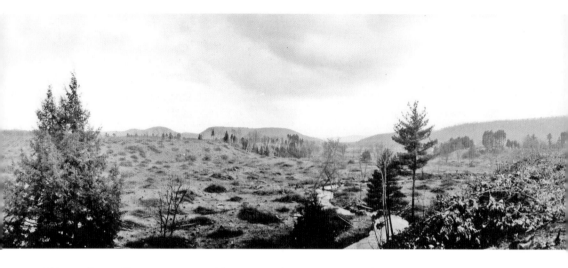

NORTH DANA TRANSFORMED: After trees and vegetation were cleared for the reservoir floor, the once-bucolic landscape was further scarred by the great hurricane of September 1938. The reservoir's waters gradually obscured the village site as they backed up from the southern end of the valley after 1939. In the background are the hills of the Swift River Valley and 'The Pass', the distinct notch between Mount L and Soapstone Mountain.

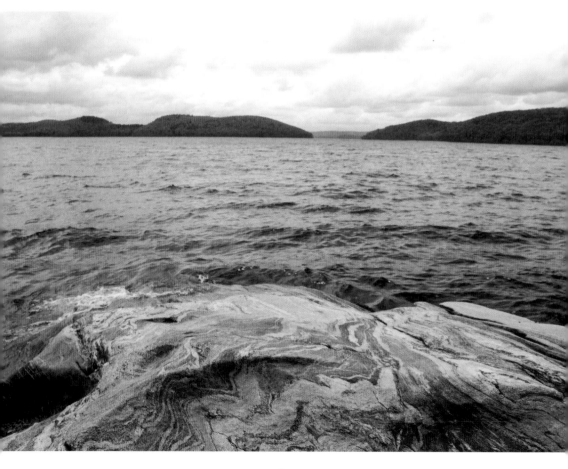

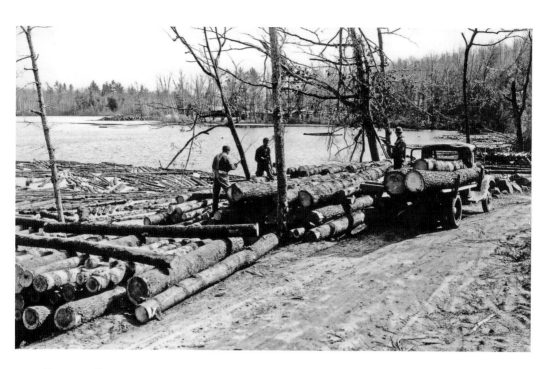

BASSETT POND: In the aftermath of the 1938 Hurricane, this was one of many lakes and ponds in central New England that were used to store fallen logs, which mitigated the considerable forest fire hazard the damaged timber posed. It is part of a series of wetlands below Bassett and Fairview Hills at the reservoir's northern tip in New Salem. The pond is now undeveloped and an excellent place to view wildlife such as river otters and flocks of migratory waterfowl.

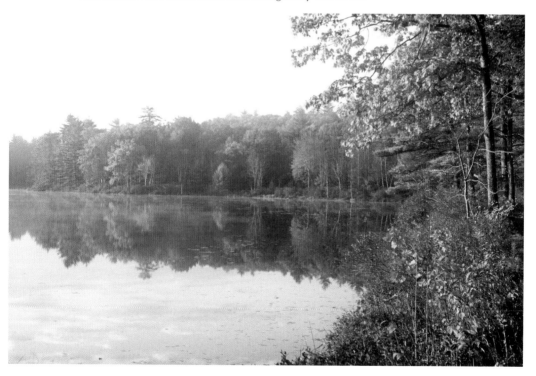

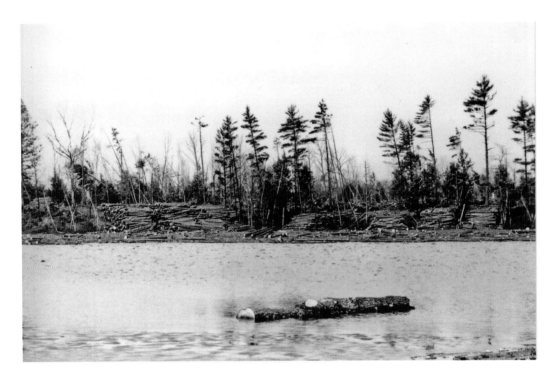

HACKETT CAMP: Bassett Pond is also known as 'Hacker Pond' after a campground owned by Harry Hackett that once encompassed 270 acres along the west shores. Hackett's cabin was situated on the edge of a small peninsula at the water's edge. A tall chimney and square cement foundation mark the cabin site today. The building was moved to West Brookfield in 1944.

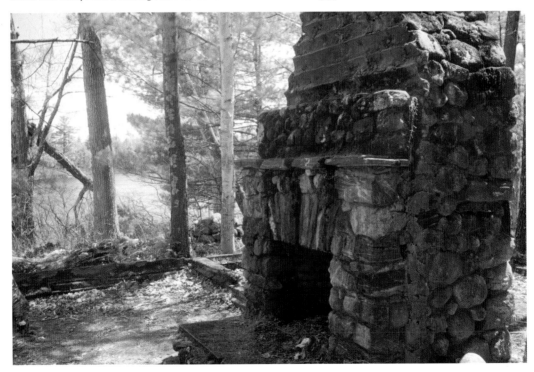

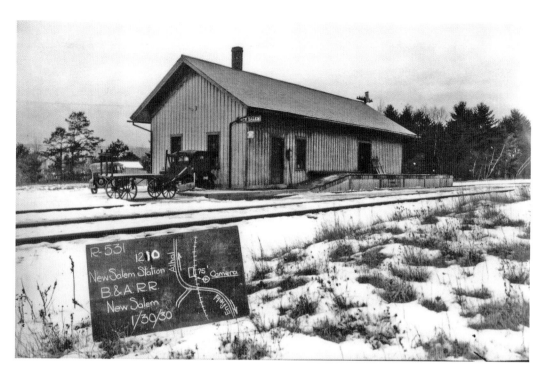

NEW SALEM STATION: The road from Gate 35 follows a portion of the old 'Rabbit Run' railroad bed past the site of this depot, which was the last of the main stops along the forty-seven-mile line in the Swift River Valley below South Athol. When water levels are low, the old foundation is visible adjacent to the Gate 35 road. The broken pavement remains of the northern portion of Route 21, another key transportation artery across the valley, are also visible here.

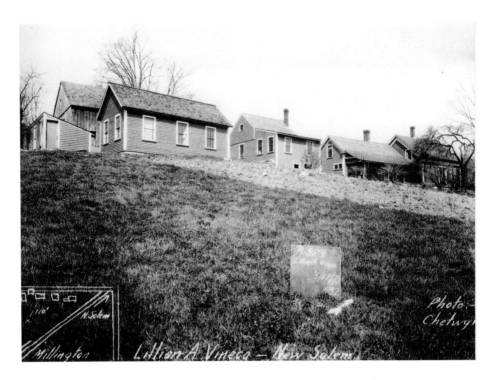

NEW SALEM: Though this picturesque town near the reservoir's northwest corner escaped the fate of the neighboring Swift River communities, a considerable amount of its residential land was taken over by the Water Commission. One of the lost homes near the town center was the residence of Elisha Vinica, a former postmaster of North Dana. Concrete steps mark the home site, which was located near the junction with the road to Puppyville above the shoreline.

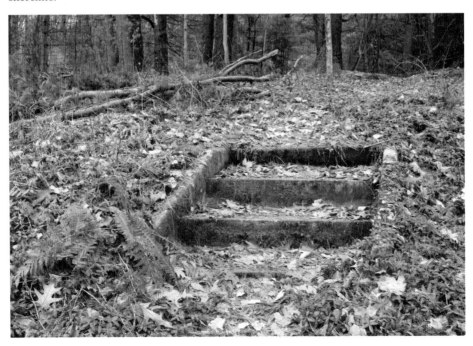

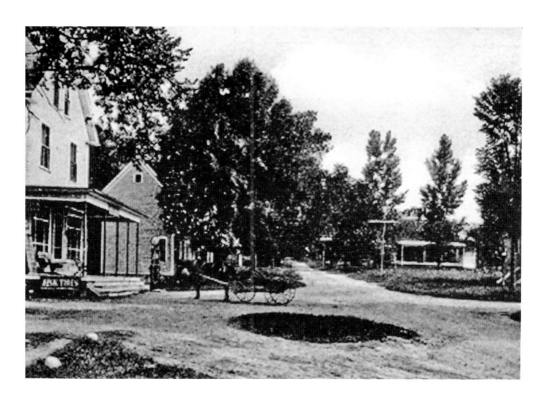

MILLINGTON CENTER: Now underwater, New Salem's largest village was nestled in the valley lowlands roughly halfway between the town center and North Dana. Among its institutions were a post office, grammar school, cheese factory, and creamery. The former Orange-Millington stagecoach road, accessed at Gates 29 and 30 in New Salem, now ends at the reservoir shores near the base of Rattlesnake and Pittman Hills.

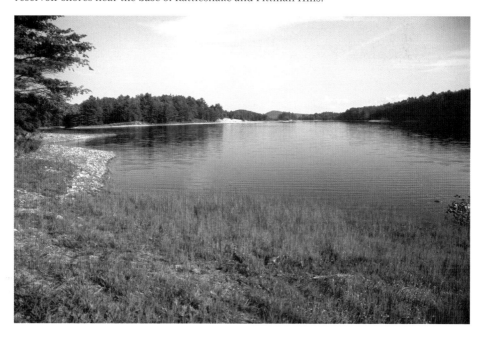

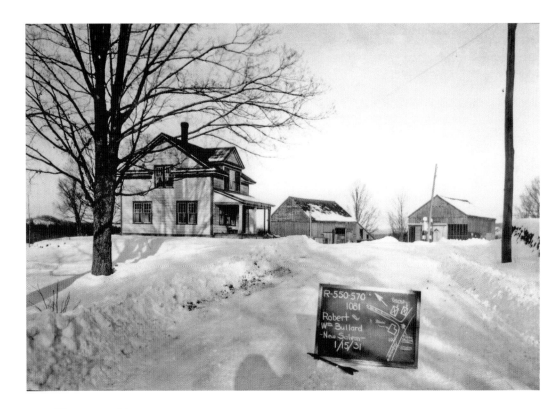

HERRICK'S TAVERN: Many travelers along the Orange-Millington Road enjoyed a pleasant rest stop and meal here at the Bullard's Corner road junction. After it burned in 1912 the property was purchased by Robert Bullard, who built a home that was moved to Athol in 1939. Today the road, accessed via Gates 29 and 30 in New Salem, offers a pleasant walk past a series of wildlife meadows lined with old sugar maples and the historic 'Keystone' stone arch bridge.

MOORE'S HALL: In May 1938, this popular community center in Millington hosted a 'last supper,' one of several ceremonial events held in the lost towns before they were officially discontinued. It was built by and named for businessman William Moore. The building was moved to Ware, where it was rebuilt as a sportsmen's club. Though the village is underwater now, an overlook near the historic New Salem town common offers an overview of its former site in the valley.

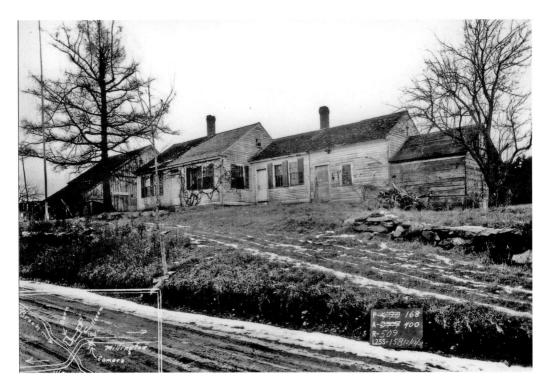

PUPPYVILLE VILLAGE: Reputedly named after an unknown nineteenth-century resident with an affinity for canines, this small hamlet was located south of New Salem center. The town's first grist mill was established here along Hop Brook, which is now one of Quabbin Reservoir's many sources. Several homes were clustered near the brook crossing, including the seven-room Furneaux residence. The old foundations are visible along the road from Gate 22.

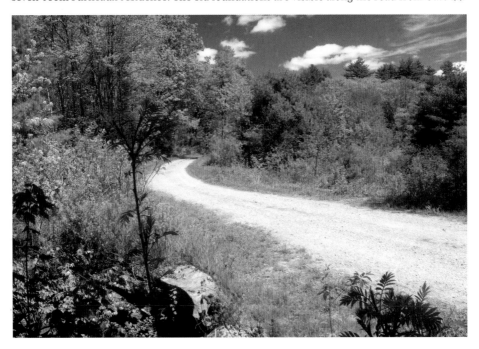

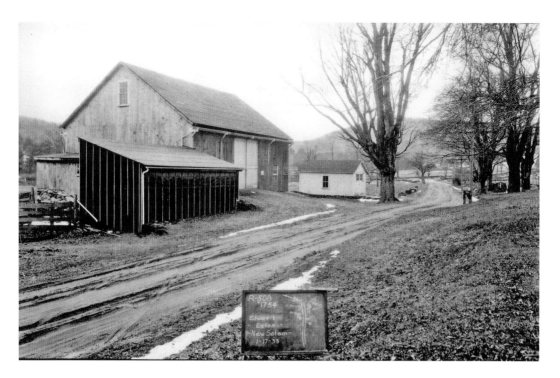

EATON HOME: Puppyville is one of Quabbin Reservoir's most accessible lost villages, as it is easily reached via a short walk from Gate 22. The bend in the road at the brook crossing serves as a useful landmark for locating the old foundations. The house of Edward Eaton was located just east of the curve on the south side of the road. The contemporary view was taken from the opposite side of the curve.

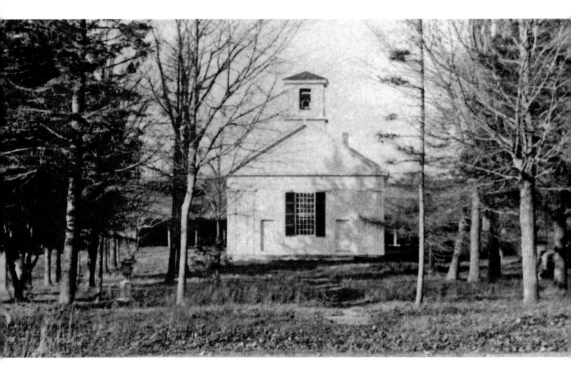

PRESCOTT CHURCH: Mostly situated on a long ridge (now closed to public access) between the West and Middle Branches, Prescott was the smallest of the lost towns. The town's former Congregational Church was moved to South Hadley by Joseph Skinner, where it reopened as a museum in 1932. Since 1946, it has been part of Mount Holyoke College, and continues to be used for exhibits. An astronomy observatory was built on the town center site in 1969 and removed in 2011.

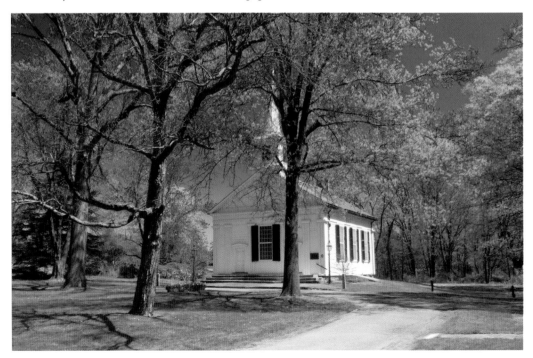

PACKARDVILLE VILLAGE:
The Union Congregational Church, which was built in 1871, was a landmark of this tiny hamlet, which is another of Quabbin Reservoir's lesser-known lost neighborhoods. It was once part of Pelham, another town that had land taken for the reservoir. After passing roughly a dozen former home sites, the former town road now ends at the Pelham Fishing Area east of the village site.

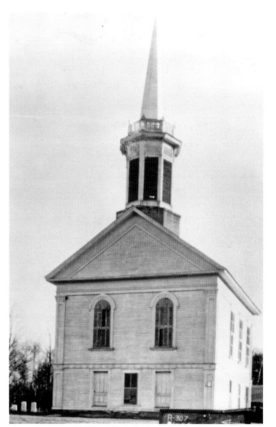

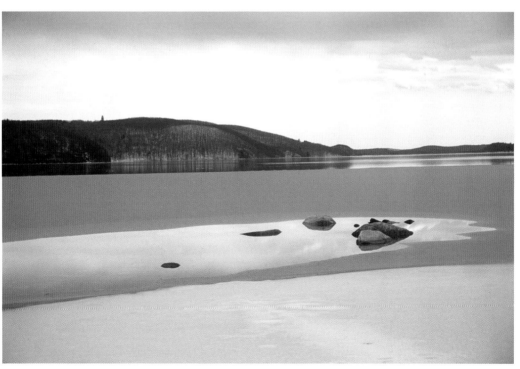

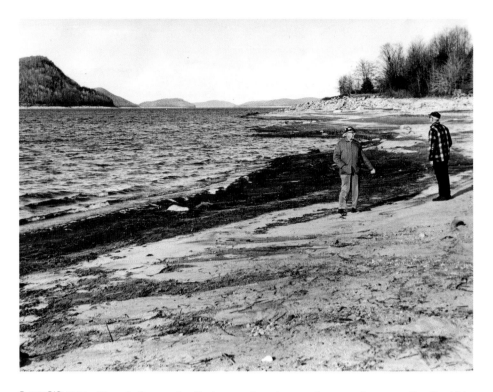

LOW WATER: Though the greater Boston area's water supply seemed secure after Quabbin Reservoir opened, within just twenty years the state faced yet another crisis when the reservoir dropped below half its capacity during the great Northeast drought of the 1960s. Many of the old foundations and roads eerily reemerged, which allowed some former Valley residents to revisit their old neighborhoods. A lesser dry spell exposed mudflats and the old Skinner Hill Road at Grave's Landing in 2002.

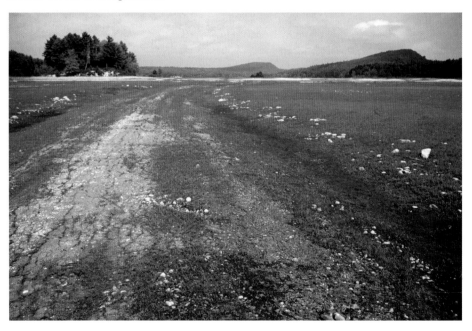

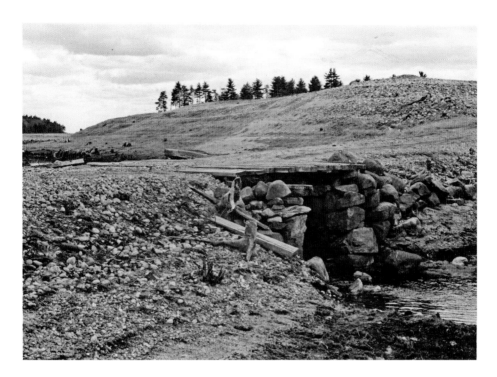

CHANGING WATER LEVELS: After the drought ended, Quabbin Reservoir did not reach capacity again until 1976. It has been full from the mid-1940s to 1961, 1976 to 1984, 1991 to 1998, and 2005 to 2010. The drought was a blessing in disguise, as it triggered debates, including an aborted proposal to divert portions of the Connecticut River that ultimately led to the enactment of successful conservation measures in eastern Massachusetts. By summer 2003, Graves Landing was again underwater (below).

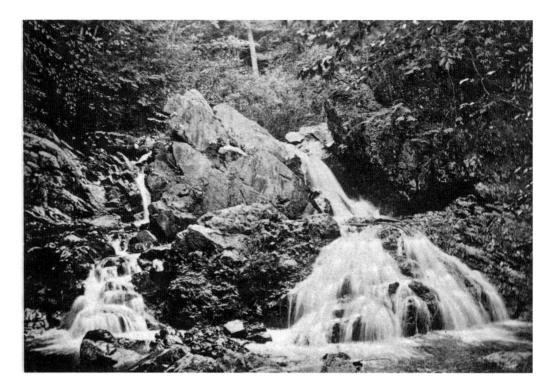

THE BEAR'S DEN: Beyond Quabbin Reservation's boundaries, the reservoir's many source waters are protected by a network of extensive conservation areas in the Swift River watershed. Upstream from its confluence with the reservoir in New Salem, the Middle Branch of the Swift River churns through this waterfall and gorge, which draws its name from an early settler who reputedly killed a bear there. It is protected today by the Trustees of Reservations, a private Massachusetts conservation organization with more than 100 properties statewide.

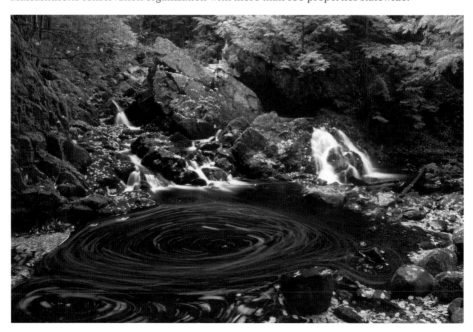

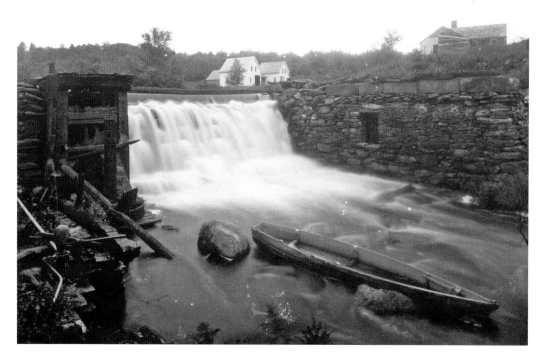

SWIFT RIVER EAST BRANCH: From headwaters in Phillipston, Quabbin Reservoir's largest source meanders eleven miles through another corridor of protected land. In a picturesque hollow in Petersham, its waters flow over a historic milldam at Brown's Pond. Further downstream, it slices through a deep glacial valley, where several conservation areas including the Swift River Reservation, Brooks Woodland Preserve, and Rutland Brook Wildlife Sanctuary combine to protect more than 3,000 acres.

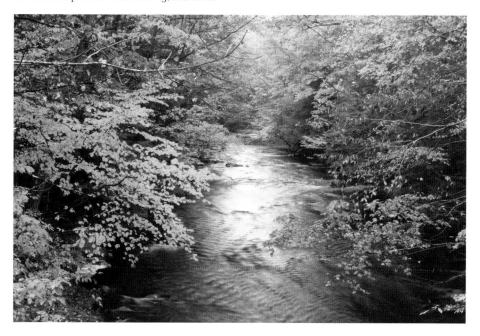

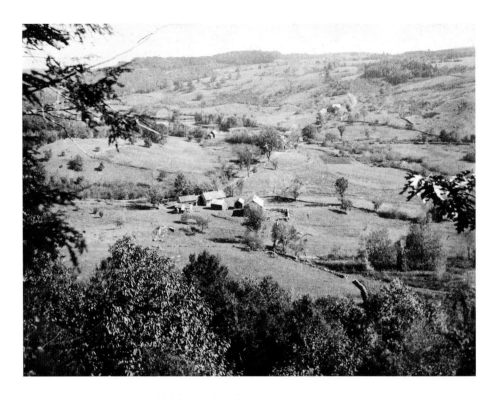

SWIFT RIVER VALLEY C. 1890 AND 2003: Even before the creation of Quabbin Reservoir, the landscape of central Massachusetts has changed significantly since colonial times. After early settlers cleared most of the forests for agriculture, many of the farms were abandoned during the nineteenth century because of the rocky, inhospitable soils. The historic view of the valley of the East Branch of the Swift River in Petersham was taken around 1890. The maturing forests, which ensure water quality, are evident in the contemporary view.

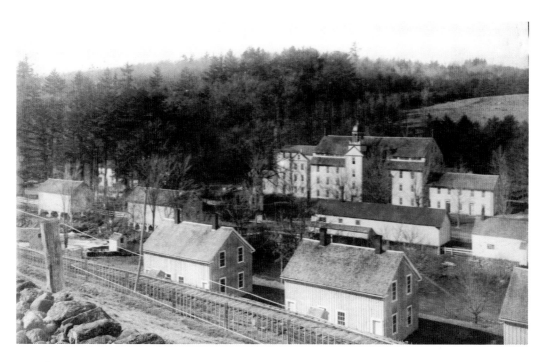

WHITE VALLEY: The lost villages of the Ware River Valley are a relatively little-known component of the history of water supply in Massachusetts. As part of the water system expansion during the 1930s, aqueducts were built to convey water from the river to Quabbin and Wachusett Reservoirs. Land takings for the project included a mill village in the southeast corner of Barre that was known as 'White Valley,' 'Smithville' and 'Clarks Mills' after the various families that owned the industrial complex.

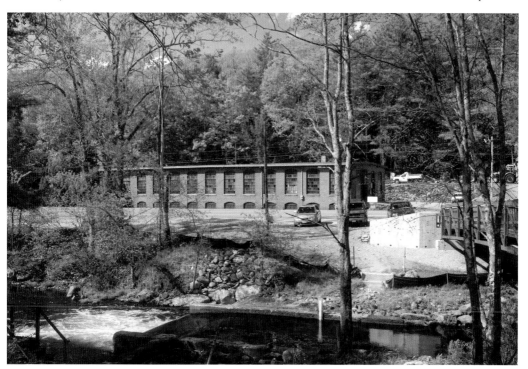

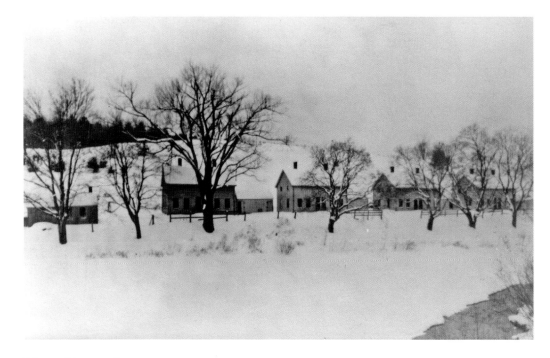

WHITE VALLEY TENEMENTS: The mill workers lived in company housing on both sides of the Ware River, which is visible on the bottom right of the top image. Benjamin Clark first established the complex in 1825, then it became the Boston & Barre Manufacturing Company in 1832. It provided employment to roughly 125 people, many of whom moved to the area from other regions of New England. The mill shut down in 1925 and all but one building were razed in 1936.

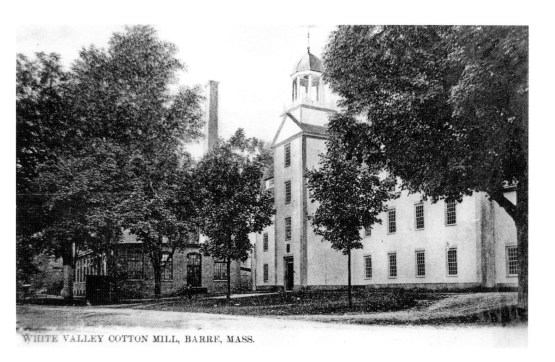

WHITE VALLEY COTTON MILL, BARRE, MASS.

WHITE VALLEY COTTON MILL: The main company buildings were located on the north side of the present Massachusetts Water Resources Authority intake facility. The brick weave shed on the left, which was converted to a garage that is still used today, is the only building left from any of the lost Ware River villages. It is easily viewed on the north side of Route 122 near the Barre-Oakham town line.

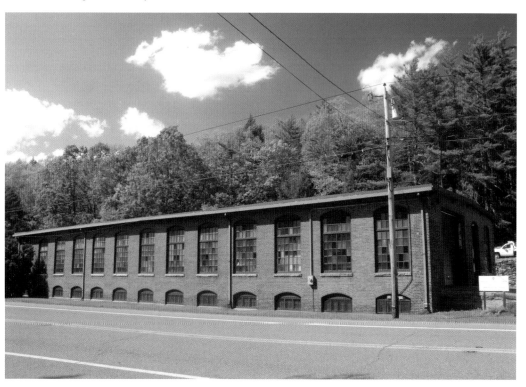

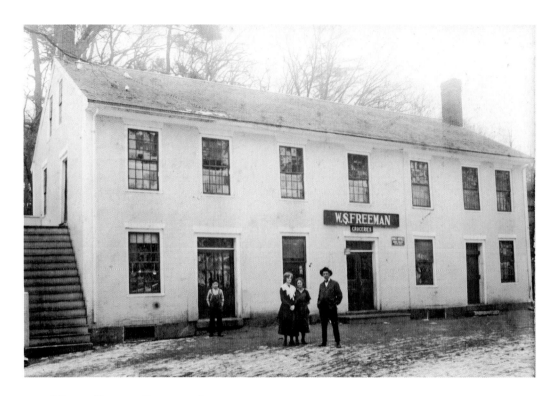

WHITE VALLEY GENERAL STORE: This two-story structure, with its wide exterior staircase, was a popular village gathering place. It was located west of the mill on the north side of Worcester Road and the Ware River. Its proprietors included Wallace Freeman and Addie Smith, who was appointed as village postmaster in 1904. The family sold the store after her death in 1918. A well-maintained recreational trail now parallels the Ware River past the dam and village site.

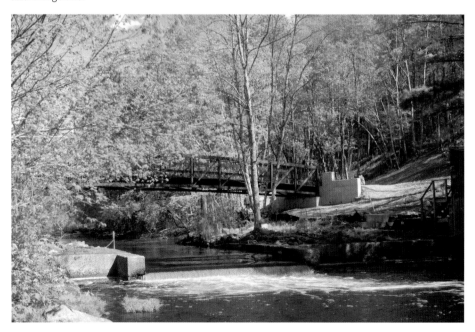

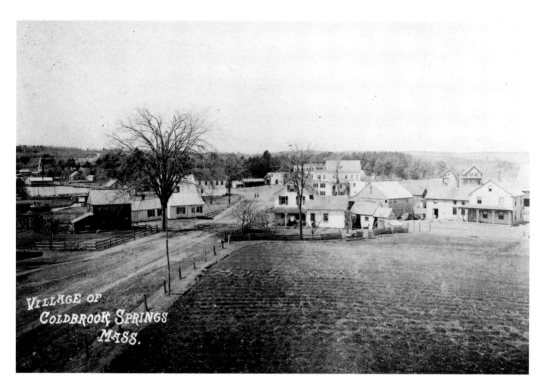

COLDBROOK SPRINGS: Named for its mineral springs that were reputed to have healing powers, this village was the northernmost of the two main residential areas in the town of Oakham. Situated along the Ware River upstream from White Valley, it developed into a small industrial center during the mid-nineteenth century. By the 1860s it was home to two hotels, a blacksmith shop, store, post office, several mills, a billiard hall, railroad station, and roughly ten homes.

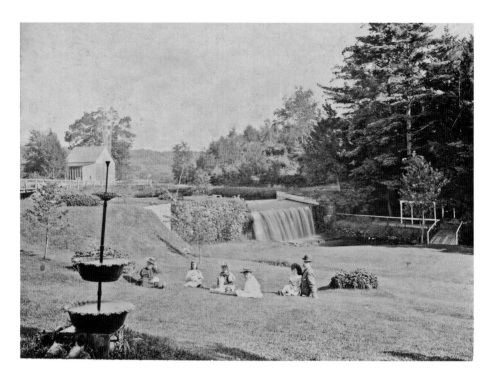

A RESORT CENTER: After its industrial heyday, Coldbrook Springs was best-known for its hotels in its latter years. The village was a popular stop for travelers on the Barre-Worcester stagecoach line. The Springs Hotel was named for the mineral springs on the grounds, which were believed to cure a variety of ailments. The proprietors sold bottled water to guests and customers throughout the country. Only traces of the old wells remain near the former hotel site today.

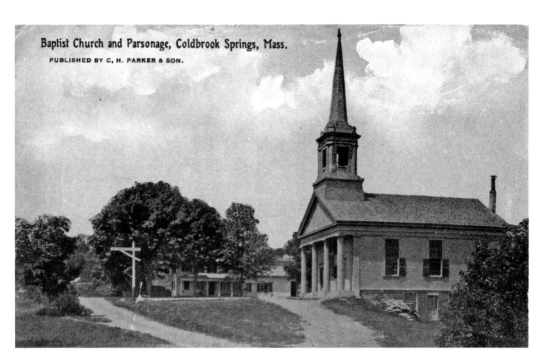

BAPTIST CHURCH: This landmark of the northern portion of Coldbrook was situated adjacent to the railroad station where the Boston and Albany Railroad crossed the Ware River. Roughly 100 people lived in the village, which was first settled in 1748. Though nature has reclaimed and largely obscured the historic sites, a stone monument at the junction of Coldbrook Road and Route 122 marks the lost community.

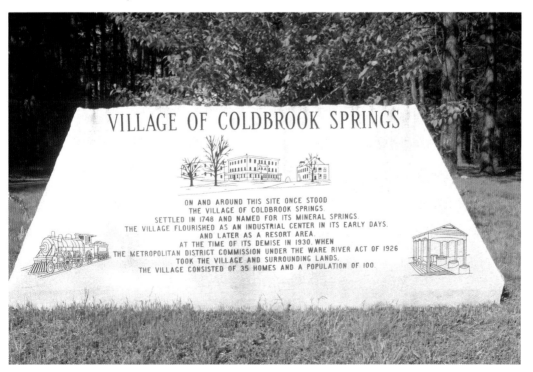

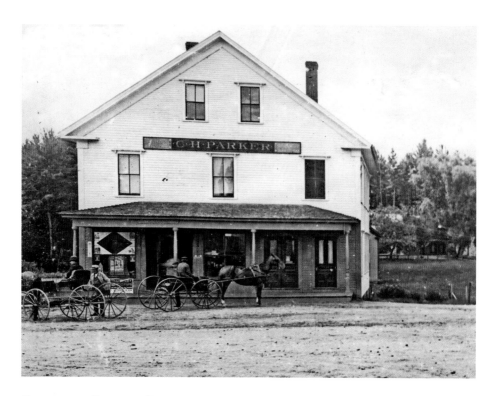

COLDBROOK GENERAL STORE: The Parker family, which established a successful sawmill in Coldbrook Springs during the mid-nineteenth century, was one of the village's most influential families. Proprietor Harry Parker, who also served as village postmaster and held several town and state government offices, regularly offered advice and council to his customers. In some years, white-winged crossbills and other uncommon winter finches frequent the spruce and pine groves that now obscure the old building sites.

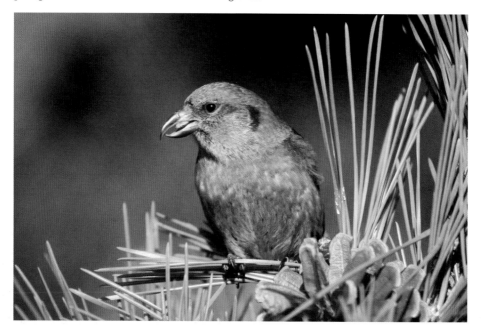

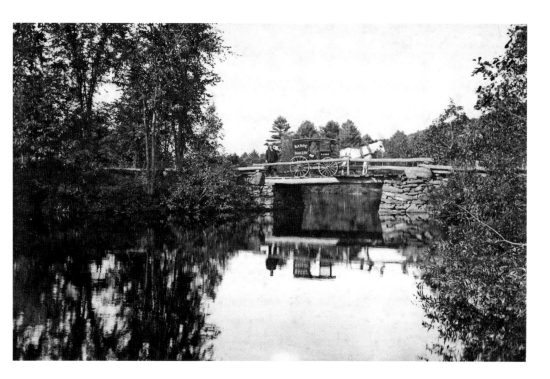

WARE RIVER: The Barre Bakery delivery wagon was a familiar sight along the valley country roads. Today the same old dirt roads offer visitors access and recreational opportunities within the expansive Ware River Reservation, which combines with Barre Falls Dam and Rutland State Park to form one of Massachusetts' largest conservation areas. The forests, wetlands, and meadows are home to a wide variety of wildlife, including a growing moose population.

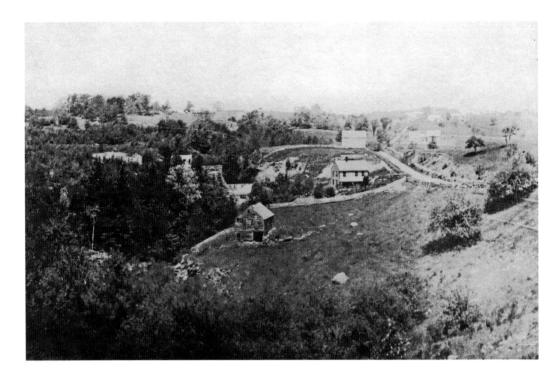

BARRE FALLS: Described by author Walter Clark as 'one of the beauty spots of Massachusetts', this picturesque, less-traveled valley was scoured by the Ware River, which meanders through a series of cascades, pools, and geologic potholes. The land was acquired by the Metropolitan District Commission during the 1930s. The fields around Barre Falls Dam are now part of a popular recreation area that includes boat launches, a disc golf course, and wildlife viewing areas.

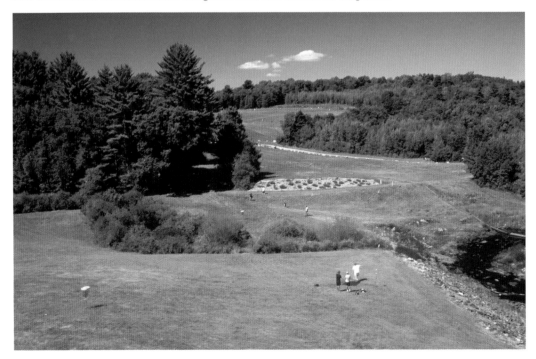

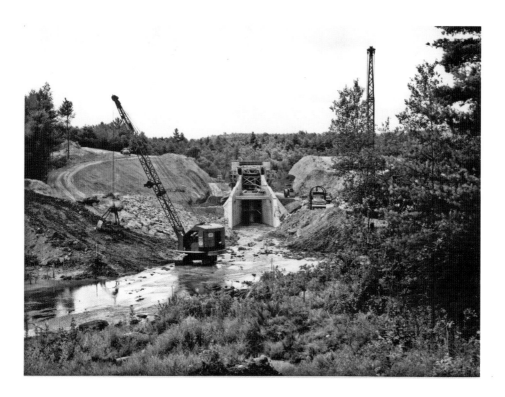

BARRE FALLS DAM: Part of a network of flood-control dams that were built in the Connecticut River watershed after the devastating storms of the 1930s, this hefty impoundment was built between 1956 and 1958 by the Army Corps of Engineers. Over the past half-century, it has saved the downstream Ware River communities millions of dollars of flooding damage. The Midstate Trail, a ninety-two-mile-long footpath that passes many attractions in central Massachusetts, passes through the recreation area.

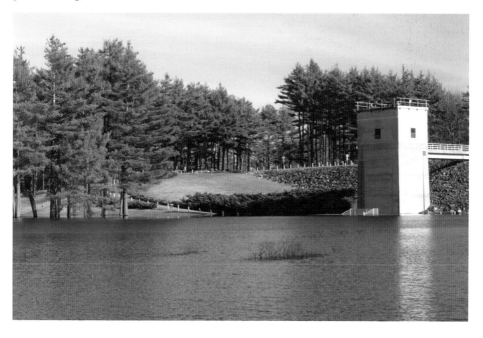

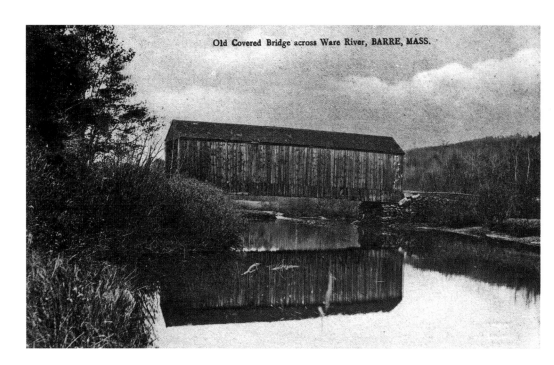

BARRE COVERED BRIDGE: Also known as the 'Cemetery Bridge' because of its proximity to the Riverside Cemetery, this less-traveled crossing spanned the Ware River downstream from Barre Falls. After it was washed away by the 1938 Hurricane floodwaters, no replacement was ever built at the remote location. The large stone abutments are still evident on both sides of the river. There are excellent wetland views from the bridge site.

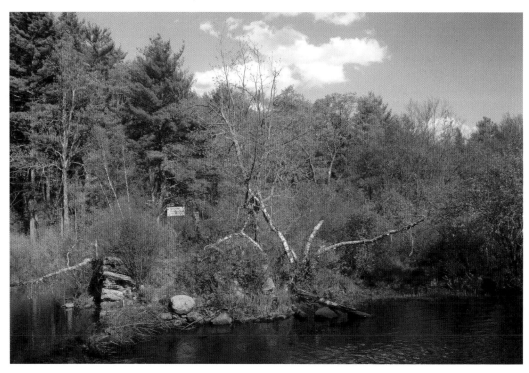

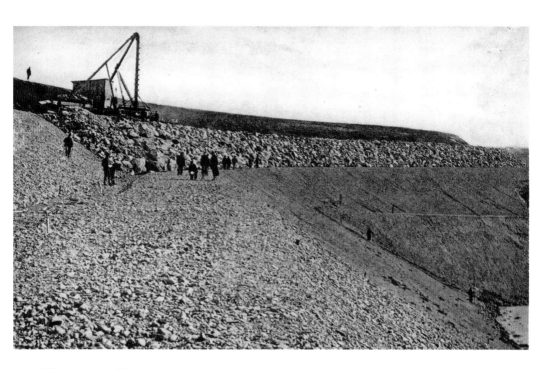

WACHUSETT RESERVOIR: Formed by an impoundment of the Nashua River near Worcester, Quabbin Reservoir's older and smaller sibling was built between 1895 and 1905. The main dam (below) is flanked by two dikes that help contain the water. The North Dike (above) is comprised of two sections of 6,500 and 4,300 feet, and has a maximum height of sixty-five feet. Both dikes were reinforced with stones that were extracted from the floor of the future reservoir.

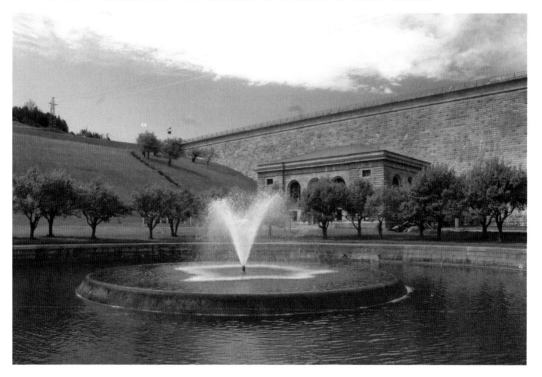

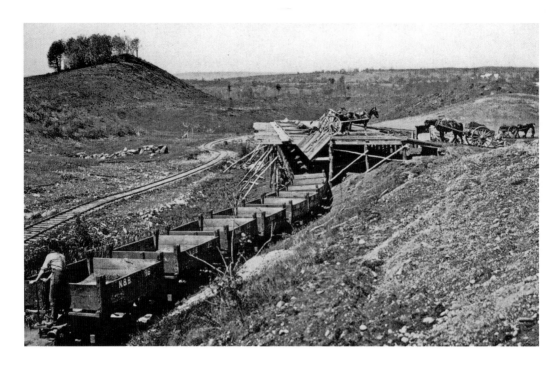

CLEARING THE BED: To prepare the floor for the Wachusett Reservoir, nearly 4,000 acres of topsoil was stripped to a depth of one foot. The considerable excess soil was removed via a narrow-gauge railroad system that included 725 cars, twenty-five locomotives, and nearly thirty-miles-worth of tracks. After the reservoir was completed, it became a popular destination for fishermen, wildlife watchers, and walkers. The second-largest lake in Massachusetts, it also hosts several pairs of common loons.

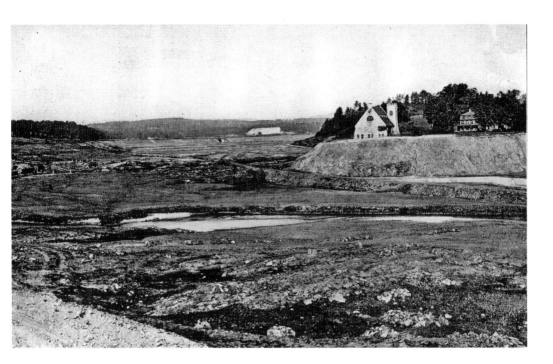

OLD STONE CHURCH: Originally built in 1891 as a replacement for a Baptist church that was lost in a fire, this is the only building remaining from the lost neighborhoods of the Wachusett Reservoir watershed. Located on the shores of the Thomas Basin, the reservoir's northwestern arm, it is a popular visitor attraction. Roughly 1,700 residents were dislocated by the reservoir, which set an ominous precedent for the Swift River Valley towns.

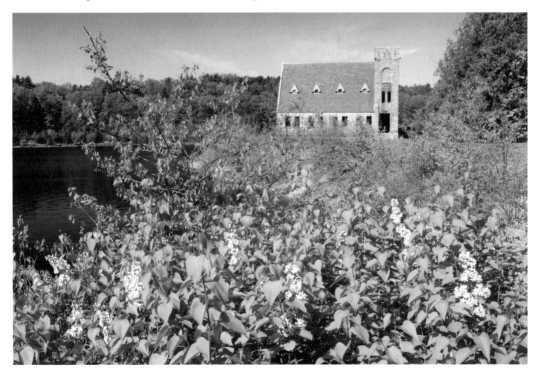

Acknowledgments

Special thanks are due to several local organizations and individuals for invaluable assistance and support with the historical images and resources that made this project possible.

Thanks to Clif Read and the Massachusetts Department of Conservation and Recreation's Quabbin Park Visitor center, to Bertyme Smith and the staff of the Barre Historical Society, to Nancy Allen and the Petersham Historical Society, and Jane Aryata and the Petersham Memorial Library.

For additional sources, thanks also to Stephanie Young and the Woods Memorial Library in Barre, Bob Clark and the Friends of Quabbin, the Athol Public Library, the New Salem Public Library, and Harvard Forest. Thanks also to Quabbin Reservoir and Ware River historian J. R. Greene, whose numerous books and atlases that have preserved the history of the lost communities, and facilitated their exploration.

Thanks to Alan Sutton and Fonthill Media, including Heather Martino and Sarah Parker for the opportunity to pursue this project and pulling all the material together.

All contemporary photographs taken by the author with the exception of page 31, which was taken by Clif Reade.